3000 800056 38676
St. Louis Community College

D1490690

AVBREY
BEARDSLEY

and the Nineties

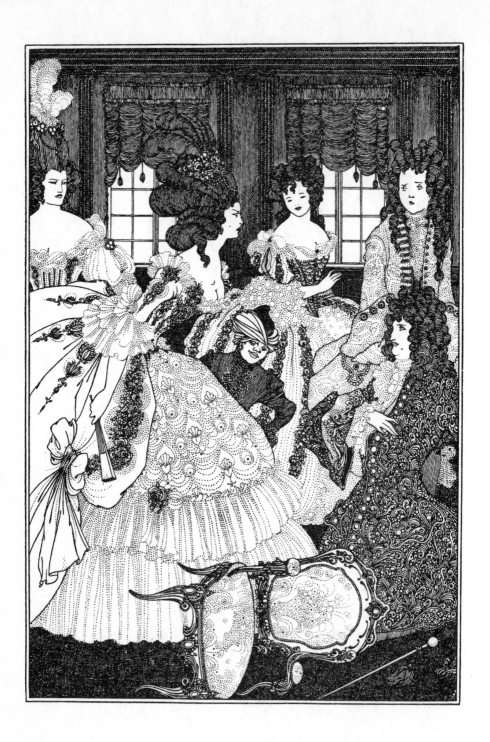

AVBREY BEARDSLEY

and the Nineties

Peter Raby

COLLINS & BROWN

First published in Great Britain in 1998
by Collins & Brown Limited
London House, Great Eastern Wharf
Parkgate Road, London SW11 4NQ

1 3 5 7 9 8 6 4 2

British Library Cataloguing-in-Publication Data:
A catalogue record for this book
is available from the British Library.

ISBN 1 85585 495 3 (hardback edition)
ISBN 1 85585 611 5 (paperback edition)

Conceived, edited and designed by Collins & Brown Limited

Editorial Director: Colin Ziegler
Editor: Elizabeth Drury
Art Director: Roger Bristow
Designer: Helen Collins

Reproduction by CH Colour Scan
Printed and bound in Great Britain
by Butler & Tanner Limited

Front cover
Photograph of Aubrey Beardsley taken
by Frederick Henry Evans in 1894.

Back cover
Cul-de-lampe to *The Pierrot of the
Minute*, 1897.

Endpapers
La Beale Isoud at Joyous Gard, *Le
Morte Darthur*, 1892-4.

Frontispiece
The Battle of the Beaux and the Belles,
The Rape of the Lock, 1896.

CONTENTS

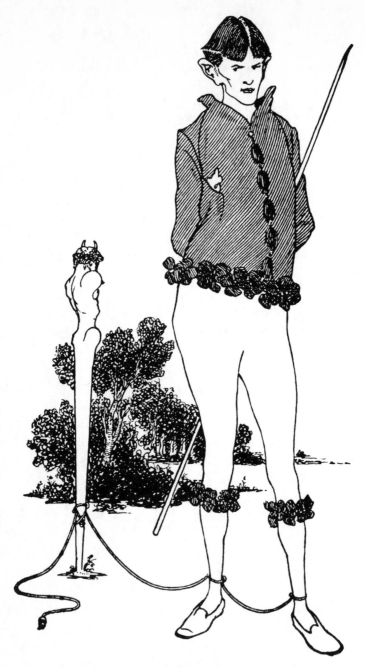

A Footnote

Aubrey Beardsley's self-portrait, depicting him with
faun's ears and a draughtsman's pen, and bound to
the god of Nature. The drawing precedes the
second instalment of 'Under the Hill', in the second
number of *The Savoy*, April 1896.

INTRODUCTION

B EARDSLEY WAS A phenomenon, the possessor of one of the most unusual artistic talents of the nineteenth century. During his own lifetime, and only two years or so after he began to publish his work, his friend Max Beerbohm could write of 'the Beardsley period'. His art expressed a time, and a movement.

He was unusual in being almost exclusively a graphic artist, an illustrator rather than a painter. His genius was for drawing, and line, and he embraced the opportunities offered by photo-mechanical reproduction as though they had been invented specially for him. This meant that Beardsley's work was public, accessible and unmissable. It confronted the late Victorians from magazine covers and advertisement hoardings. They might not like it, but they could not ignore it. Other artists certainly responded: in Paris, Henri de Toulouse-Lautrec and Alfred Jarry; in Moscow, Alexandre Benois and Léon Bakst.

Beardsley's art was to percolate through the twentieth century, not least in the theatre, where his influence can be traced in Bakst's designs for Diaghilev's Ballets Russes, in the work of Charles Ricketts and in the more specific references of productions of Oscar Wilde's plays, notably John Gielgud's 1930 'black-and-white' *The Importance of Being Earnest*, and Steven Berkoff's *Salome*.

Beardsley started to study as a professional artist when he was nineteen, and began his astonishing, brilliant and brief career almost simultaneously. He was able to work for a period of six years, and for much of that time only intermittently, before the effects of tuberculosis overwhelmed him. Yet, in that short span, he developed a style, and a range of subject matter, that was seen as the epitome of a decade, by the approving and the disapproving alike. In a

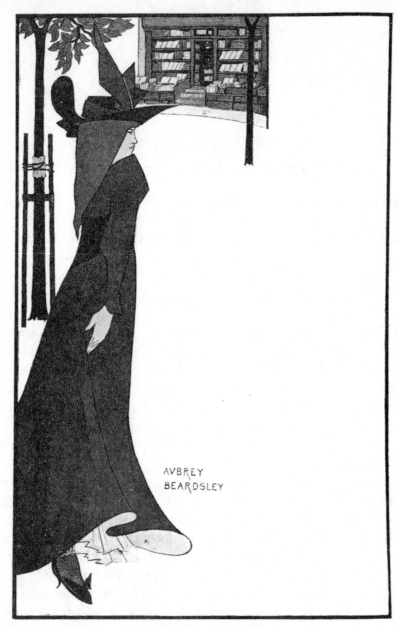

Design for a poster
The drawing, reproduced as a colour lithograph in
1894 for the advertisement for T. Fisher Unwin's Pseudonym
and Autonym Libraries, shows Beardsley's New Woman
outside a bookshop.

country that specializes in scepticism towards the visual arts, that is hostile to innovation and where young talents are not often made welcome, Beardsley's sudden appearance, and his comet-like trail through the eighteen-nineties, were remarkable; the fineness of his technique, and the quality of his drawings, combine to make him unique. In Paris, he would not have been conspicuous, but in England his genius, and his personality, were not what people were used to.

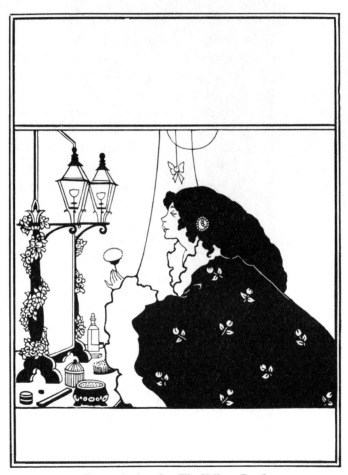

Cover design for *The Yellow Book*
Volume III, October 1894. A slightly oriental, certainly exotic, lady of the night prepares her toilette. There is no image in the dressing-table glass, lit by street-lamps – a provocative touch typical of Beardsley.

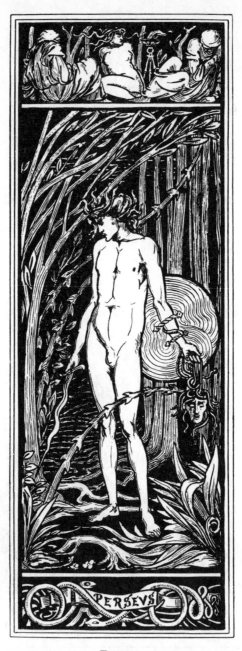

Perseus
The design of this drawing, in pen and
ink and light wash, is in the style of Edward
Burne-Jones, whom Beardsley first met
in July 1891. Burne-Jones recognized that
Beardsley had 'every gift which is
necessary to become a great artist.'

PORTRAIT OF THE ARTIST
AS A YOUNG MAN

AUBREY BEARDSLEY WAS born on 21 August 1872 in Brighton, the Sussex seaside resort that still carries those overtones of the fashionable, and the faintly louche, that it acquired through the Prince Regent in the first years of the nineteenth century. Beardsley's mother Ellen was the daughter of an East India Company surgeon named William Pitt, whose wife was the daughter of a Scots indigo planter. This combination of trade and empire was solidly Victorian and predictable, leading to early retirement and quiet respectability, but Ellen made a slightly unconventional marriage. She met Vincent Paul Beardsley on Brighton pier – a chance encounter; they were not introduced. Vincent came from London, where his father had been a goldsmith; in other words, he was 'in trade'. Vincent's father had died of tuberculosis, and he himself was consumptive. He did not have a profession. According to Ellen Beardsley's own account, long afterwards, the engagement was not looked upon with much enthusiasm by her parents. But she was married from her father's house on 12 October 1870.

Vincent Beardsley did not have very much money, and he managed to lose most of what he did have rather rapidly. A clergyman's widow threatened to bring a case against him for breach of promise to marry, timing this to coincide with Vincent's and Ellen's honeymoon. Some property was sold, and the case was settled out of court. As the money vanished, so did the marriage.

Both the Beardsley children were born in the Pitt family home in Buckingham Road, Brighton, Mabel on 24 August 1871, and Aubrey a year later. Vincent Beardsley had to give up his self-sufficient status of gentleman and take a job, first for the West India and Panama Telegraph Company, then for two London breweries.

He became an increasingly shadowy figure in the close circle of the family, a family dominated by a protective mother forced to work to sustain her two children, as a governess and by giving piano lessons.

Aubrey was, from the moment of his birth, a frail child. When he was seven he had his first attack of tuberculosis, and was sent off to school at Hurstpierpoint, a few miles from Brighton on the Sussex Downs. The seven-year-old Aubrey's letters home are in a series of short, factual sentences, clearly composed for the eye of Miss Wise, his headmistress:

> The boys do not tease me. I like Hurst very much
> … How do you like Margate? My knee is better. I
> am quite well. I received your letter this morning;
> thank you for it. I am very happy. I hope Mabel is
> quite well.

He wrote this from Hamilton Lodge in October 1879 and, at the end of November, with more of a flourish, perhaps dictated:

> Miss Wise wishes me to tell you that the holidays
> will begin of Saturday the 20th instant, when I
> shall be very glad to see you all again and hope
> you will be pleased with the progress I have made
> in my studies during the past term. P.S. Send me
> the money for my journey.

The atmosphere at the school was probably more relaxed and affectionate than at most – he wrote about games and expeditions to fêtes and the circus, and, close to his mother's interests, his progress in music, though Ellen afterwards claimed that 'he was beaten by the schoolmistress to force him to cry, but he refused and she had to give in'.

In 1881 Aubrey was removed to Epsom, on the north Surrey Downs, 'to get strong'. One result of this was his first commission, to make some drawings for Lady Henrietta Pelham, a friend of his mother who was probably finding a tactful way to help the family. 'The drawings which I sent you were all copies from different books,' he wrote. 'I often do little drawings from my own

King John Signing the Magna Carta
A comic sketch of c. 1886, drawn by
Beardsley in a history book while he was a
pupil at Brighton Grammar School.

A lecture on an Apple
A caricature of c. 1885-8 of Mr Marshall,
headmaster of the Grammar School, with his
hair standing up from his head like a devil's
horns, lecturing his class on an apple.

A lecture on an Apple
Another from the series of drawings saved by
Arthur King, Beardsley's housemaster. King
encouraged the boy's talent and remained in
touch with him for some years.

imagination but in doing figures the limbs are apt to be stiff and out of proportion and I can only get them right by copying.' From Epsom the Beardsleys moved to London, where Aubrey played in concerts with his sister. Then, in 1884, the two children were sent back to Brighton, where they lived with their aunt for a few months before Aubrey became a boarder again in January 1885, this time at Brighton Grammar School.

His four years at Brighton seem to have been happy. Charles B. Cochran, the future impresario, joined the school at the same time and recalled, on his first evening, sitting next to a 'delicate-looking boy, thin, red-haired, and with a slight stoop. He was a particularly quick talker, used his hands to gesticulate, and altogether had an un-English air about him.' Beardsley found a friend in Cochran, who shared his interests and would go with him to the Brighton theatres. Fortunately Beardsley's unusual talents were recognized, notably by his housemaster, Arthur King, who lent him books and encouraged him to draw. Beardsley's gift for parody was already apparent. 'My dear Miss Felton,' he wrote to a girl who was a boarder at another Brighton school:

> How can I express my feelings towards you?
> Words are too poor, alas. I couldn't get pens
> enough to write all that is contained in the inmost
> depths of my love-stricken heart … Will you be
> going to church next Sunday? If your answer is
> favourable hold a handkerchief in your right hand
> as a token that you love me.

Beardsley's verses and sketches were published in the school magazine, and he appeared, along with Cochran, in the school entertainments produced by King, which took place in the Dome of the Brighton Pavilion. Although he left the school in the summer of 1888, he was included in the school production that December, playing the part of Herr Kirschwasser in a comic opera, *The Pay of the Pied Piper*, and he designed the costumes and illustrated the programme as well.

It was probably lack of money that led to Beardsley's being taken away from school. Moving to London, and getting a temporary job

The Jubilee Cricket Analysis
Several of Beardsley's humorous drawings were printed in the Brighton Grammar School magazine in 1887, the year of Queen Victoria's Golden Jubilee.

The Pay of the Pied Piper
An illustration for the programme of a comic operetta given in 1888 as a Christmas entertainment at the school. Beardsley designed the costumes and played the part of Herr Kirschwasser.

The Pay of the Pied Piper
The rats of Hamelin Town eating the cheese, another of Beardsley's illustrations for the programme of the operetta devised by Arthur King.

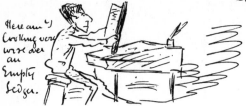

whose in your room this term?

I have been "In Business" since new years day I don't exactly dislike but am not (as yet) frankeally attached [?] wit My work however is not hard.

Here am I Cooking very wise over an Empty Ledger.

Letter from Beardsley to Arthur King

The sketch is of himself 'looking wise over an empty ledger'. He had started work at the Guardian Life and Fire Insurance Company in London at the beginning of 1889.

Programme for a home entertainment

This was for one of the skits that Aubrey and Mabel put on in the front parlour of their house in Cambridge Street. Mabel later became a professional actress.

The Cambridge Theatre of Varieties

To amuse themselves while living together in Pimlico between 1885 and 1888, Aubrey and Mabel wrote and acted in some comic sketches.

in the office of a Clerkenwell surveyor, cannot have been good for his health, though he was at least reunited with his family in Pimlico, most importantly with his sister, and able to enjoy going to the theatre. 'I have been "In Business" since New Year's day,' he wrote to Arthur King, and sketched himself at the bottom of the page 'looking wise over an empty Ledger'; 'Is the football kept up this term? And have we any chance for the cup?' he added, out of what could have been a sense of duty but which sounds a little wistful; 'I wonder if you are able to have any entertainments this term. I wish I was back to help with some.'

To compensate, he and Mabel invented The Cambridge Theatre of Varieties ('Costumier Madame Mabelle, Perruquier M. Aubré'), sketches produced, written, acted and sung by themselves, with Mabel already experimenting in cross-dressing. It was more satisfying than being a clerk for the Guardian Life and Fire Insurance Company in Lombard Street. A year later he was writing again to King from his sick bed. He had been 'dreadfully ill', with a bad attack of blood-spitting, had had to leave the insurance office (temporarily, as it turned out) and had spent Christmas 'on slops and over basins'. But he had done some writing, and had received £1 10s. from *Tit Bits* for 'The Story of a Confession Album'. The pattern of bouts of illness alternating with bursts of creativity was already established.

He went back to the office, where the work was neither stimulating nor particularly demanding, so his energies could go into reading, and drawing, and going to theatres and exhibitions. Another patron appeared, the Reverend Alfred Gurney, vicar of the High Anglican church of St Barnabas, Pimlico. Ellen Beardsley had first met Gurney when he was a curate in Brighton. The Beardsleys were regular church attenders, and Aubrey was strongly attracted to the ceremonial of the Anglo-Catholic tradition, with its emphasis on visual beauty, ritual and choral singing. Alfred Gurney, like his former housemaster, encouraged Beardsley, lent him books and gave him small commissions.

Soon Beardsley was drawing regularly, in between visits to the National Gallery with Mabel, or to Hampton Court Palace to see the Mantegna cartoons. 'My latest productions are Ladye Hero, Litany of Mary Magdalen, La Belle Dame, Mercure de Molière,

Griselda,' he wrote to his school friend George Scotson-Clark in July 1891. He was full of his visit to Frederick Leyland's house in Prince's Gate, where he had been overwhelmed by Whistler's Peacock Room, and had seen paintings by Rossetti, Watts, Ford Madox Brown, Millais and Burne-Jones, besides Botticelli, Filippo Lippi, Giorgione and Leonardo. He was investigating joining the Herkomer School of Art; and, he ended, he was going to Burne-Jones's studio the following week.

Aubrey and Mabel thought that Burne-Jones's studio was open to visitors, and they went to 49 North End Road, West Kensington, one Sunday afternoon, only to be told that the studio had not been open for some years. They had hardly turned the corner when, wrote Aubrey to King, 'I heard a quick step behind me, and a voice which said, "Pray come back, I couldn't think of letting you go away without seeing the pictures, after a journey on a hot day like this."' Burne-Jones took them back to the house and showed them everything. 'By the merest chance' Beardsley had some of his own drawings with him, all done within the past few weeks, perhaps in anticipation of some such encounter.

Burne-Jones opened the portfolio, examined the drawings for a few moments and exclaimed, 'There is *no* doubt about your gift, one day you will most assuredly paint very great and beautiful pictures.' Then he continued looking through the rest and said:

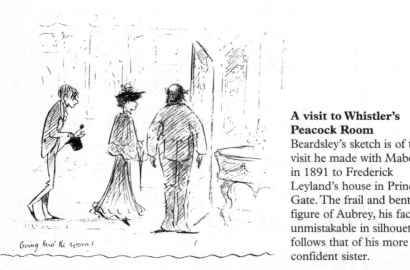

Going thro' the rooms

A visit to Whistler's Peacock Room
Beardsley's sketch is of the visit he made with Mabel in 1891 to Frederick Leyland's house in Prince's Gate. The frail and bent figure of Aubrey, his face unmistakable in silhouette, follows that of his more confident sister.

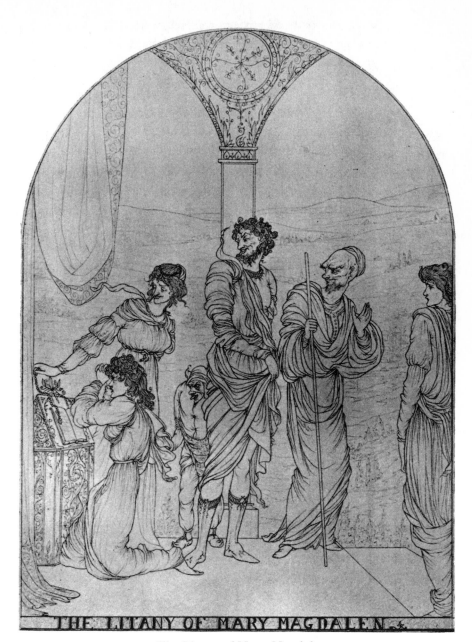

The Litany of Mary Magdalen
A pencil drawing of 1891. While echoing
Mantegna, Beardsley disrupts the act of repentance
with the expressions on the faces of Mary's atten-
dants and with the dwarfish grotesque figure that
leers from behind.

All are *full* of thought, poetry and imagination.
Nature has given you every gift which is necessary
to become a great artist. I *seldom* or *never* advise
anyone to take up art as a profession, but in *your*
case *I can do nothing else.*

'And all this,' Beardsley added for King, 'from the greatest living artist in Europe.'

The instant recognition of Beardsley's gift proved the catalyst for his total commitment to his art, a submission, in his own words, to the inevitable: 'in vain I tried to crush it out of me but that drawing faculty would come uppermost.' During tea, Burne-Jones gave advice about art training, clearly envisaging that Beardsley would progress from drawing to painting. Beardsley chose one of the two teachers recommended by Burne-Jones, Frederick Brown, who was head of the Westminster School of Art. He left Burne-Jones 'a different crit'ter', and with the invitation to return with fresh examples of his work every three or six months.

Mrs Burne-Jones was equally welcoming. Aubrey and Mabel took tea on the lawn with other visitors, including the Wildes. Then aged thirty-seven, Oscar Wilde lived in Tite Street, Chelsea, with his wife Constance and their two sons, and was nearing the height of his fame. *The Picture of Dorian Gray* had been published in book form earlier that summer, and later in the year he would begin work on *Salomé*. He and Constance walked home with Mabel and Aubrey. Aubrey, by contrast on the threshold of his career, described himself with characteristic irony: 'I am now eighteen years old, with a vile constitution, a sallow face and sunken eyes, long red hair, a shuffling gait and a stoop.'

Self-portrait
The pen and ink drawing of c. 1892 is a portrait
of the artist at the beginning of his career, full of high
intent and self-confidence, but at the same time hinting
at the physical effect of the tubercular condition that
was to cause his early death.

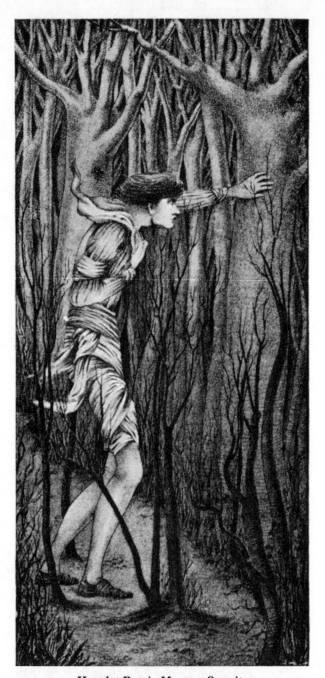

Hamlet Patris Manem Sequitur
Printed in red, this pencil drawing was published by Arthur King
as the frontispiece to the November 1891 issue of *The Bee*. Hamlet,
wrapped in a shroud-like garment, seems lost, even doomed, in the
tangled, oppressive and leafless wood that surrounds him.

'PERPLEXED WITH DOUBT'

EARDSLEY COULD NOW see himself as an artist, with Burne-Jones as his mentor – a relationship he would not sustain for very long but which was, at this critical moment, essential. In August 1891 he was living with his father in Pimlico, and 'not having a particularly lively time of it', while his mother and Mabel were in Woking for a couple of months. He dropped in to the National Gallery to see the new acquisition, Holbein's *Ambassadors* – 'a damned ugly picture I assure you' – and steeped himself in the 'simply enchanting' *Earthly Paradise* by William Morris. But his main energies were directed towards building up a collection of drawings that he could show Burne-Jones.

His latest *chef d'œuvre*, he told his friend Scotson-Clark, was Hamlet following the ghost of his father – 'Hamlet Patris Manem Sequitur'. This drawing has been thought to reflect his consciousness of the illness he shared with and had inherited from his father. There may also be an association with Ibsen's *Ghosts*, the play which especially offended Victorian taste and which Beardsley had recently illustrated. 'Farewell', he ended his letter to Scotson-Clark, as though to Horatio, adding a poem that seems to characterize the mood of the drawing:

> The lights are shining dimly round about,
> The Path is dark, I cannot see ahead:
> And so I go as one perplexed with doubt,
> Not guessing where my footsteps may be led ...
>
> The night is dark and strength seems failing fast
> Though on my journey I but late set out.

And who can tell where the way leads at last?
Would that the lights shone clearer round about!

Beardsley's days, from 9.30 to 5.30, were spent at the insurance office. Two evenings a week he attended art school, which was all that his eyes and his energy could manage. His teacher Frederick Brown, Beardsley enthused, was 'tremendously clever with the brush'; he exhibited 'A 1 work at the Academy', and he seemed to have great hopes of his pupil.

On Christmas morning 1891 Beardsley received a copy of his first professionally published illustration. His Brighton teacher, Arthur King, was now the Secretary at Blackburn Technical Institute and had reproduced the Hamlet drawing in the November number of the institute's journal, *The Bee*, with a short commentary that predicted, flatteringly but inaccurately, 'He is destined to fill a large space in the domain of art when the twentieth century dawns.' It was the best possible present. 'I scarcely knew whether I should purchase to myself a laurel wreath and order a statue to be erected immediately in Westminster Abbey or whether I should bust myself,' Beardsley wrote in ironic gratitude – and immediately went on to suggest a future contribution by himself on the subject of lines and line drawing. 'How little the importance of outline is understood even by some of the best *painters*.' (He then discovered that Walter Crane had pre-empted him in a magazine article and withdrew the proposal.)

In the first months of 1892 he was unwell, and had to stop art classes as well as his job for a while. But his reputation was growing, as the discriminating began to recognize his talent and to pass on their appreciation to others. One admirer was Aymer Vallance, who showed some of Beardsley's work to William Morris. Morris, unlike Burne-Jones, was not impressed. Vallance also introduced Beardsley to Robert Ross, who was to become a close friend as well as patron.

Recovering from his bout of illness, Beardsley evolved a new style of drawing. This was founded on Japanese art, he explained to his former housemaster:

> but quite original in the main. In certain points of
> technique I achieved something like perfection at

Sketch of Frederick Brown
Brown was Beardsley's teacher at the Westminster School of Art, and the drawing was done in *c.* 1891. The peacock feather is a glance at Whistler, whose style the drawing echoes.

Letter from Beardsley to Arthur King
Since leaving Brighton King had become Secretary to the Blackburn Technical Institute. The letter is dated 4 January 1890.

Bookmark
In 1893, when this pen and ink drawing was done, Beardsley was intrigued by the subject matter and style of Japanese art.

once and produced about twenty drawings in the
new style in about a couple of months. They were
extremely fantastic in conception but perfectly
severe in execution.

More expansively, he described the drawings to Scotson-Clark as:

something suggestive of Japan, but not really
japonesque ... The subjects were quite mad and a
little indecent. Strange hermaphroditic creatures
wandering about in Pierrot costumes or modern
dress; quite a new world of my own creation.

Beardsley took the drawings with him to Paris in June, during his
holiday from the office. A letter of introduction from Burne-Jones
won him a meeting with Puvis de Chavannes, the President of the
Salon des Beaux-Arts, who introduced him to other painters as *'un
jeune artiste anglais qui fait des choses étonnantes!'* Beardsley chose to
accept this as undiluted praise. He also visited the Rat Mort, known
as a lesbian rendezvous, the Moulin Rouge and the Chat Noir, as
well as the Louvre.

Back in London that summer, buoyed by the exhilaration of his
Paris visit, Beardsley benefited from another 'chance' encounter. At
lunch times he would often walk from the office in Lombard Street
to the Cheapside bookshop of Jones and Evans. Frederick Evans was
a photographer as well as a bookseller, and closely interested in art,
and in developments in printing. He took a number of photographs
of Beardsley, and bartered books for drawings. The publisher John
Dent was in Evans's shop one day, discussing a projected new
edition of Malory's *Morte Darthur*, to be illustrated by mechanically
produced line-block drawings instead of the woodcuts of William
Morris's Kelmscott Press: the drawings would simulate the illustrations
of Morris or Burne-Jones but would be produced for a wider market.
Evans suggested Beardsley, and Beardsley made his first drawing,
'The Achieving of the Sangreal'. He was given the commission to
illustrate the book, for a sum that he variously reported as £200
and £250. It was, by any standards, an enormous quantity of work.
'I've everything to do for it,' he told King. 'Cover, initial letters,

The Achieving of the Sangreal
Beardsley made this drawing in the autumn of
1892 as a sample for John Dent, who then
commissioned him to illustrate *Le Morte Darthur*.
Executed in Indian ink and wash, it shows the
influence of Burne-Jones and Rossetti. The
'achieving' is accompanied by disturbing,
menacing details.

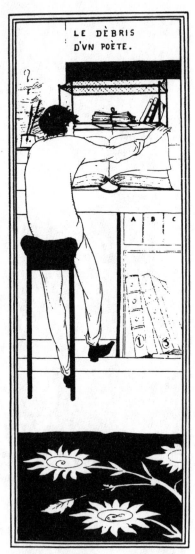

Grotesque from *Bon-Mots*
One of the unsettling images Beardsley
conceived for the series, published by
John Dent in 1893-4. The drawings are
of separate invention from the collected
sayings of such writers as R. Brinsley
Sheridan and Charles Lamb.

Le Dèbris [*sic*] d'un Poète
A pen and ink drawing of 1891-2
of the artist in the Guardian Life
and Fire Insurance office, immersed
in a ledger, which significantly,
since he loathed the job, is blank.

head-pieces, tailpieces, in fact every stroke in the book will be from my paw. I anticipate having to do at least 400 designs all told.'

He was also commissioned to do a set of sixty grotesques for three volumes of *Bon-Mots* – 'very tiny little things, some not more than an inch high, and the pen strokes to be counted on the fingers', some of them versions of his 'strange hermaphroditic creatures' suggestive of Japan. They took him ten days, and he was paid £15, his first art earnings. The *Bon-Mots* were anthologies of eighteenth-century wits such as Sydney Smith and Richard Brinsley Sheridan, and Beardsley's drawings, which included foetuses, satyrs and eunuchs as well as pierrots, images of Japanese women and figures from contemporary 'society', had no discernible relationship to the text. Then there were drawings to illustrate other new editions – Nathaniel Hawthorne's *Classic Tales*, Fanny Burney's *Evelina* and Henry Mackenzie's *The Man of Feeling* – and several more publishers were making overtures.

On the strength of this new stream of income he gave up his job at the insurance office in the autumn, 'to the great satisfaction of said office and myself', he confided to King. 'If there ever was a case of the ❑ [square] boy in the ○ [round] hole, it was mine.' He celebrated his escape from the high stool and the row of ledgers with a drawing, 'Le Dèbris [*sic*] d'un Poète'. He left the office, and told his parents afterwards; there were ructions at first, but as he achieved something like success, they began to come round, and swore they took the greatest interest in his work: 'This applies principally to my revered father.' In an earlier letter Beardsley envisaged that he and his sister would soon have the 'family' on their hands. His father was no stronger, and his mother was ill with chronic sciatica, so 'the money view' of his art work was crucial. Mabel, meanwhile, had taken the top honours in all subjects in the Higher Women's Examination, and was teaching at the Polytechnic High School in Langham Place.

Their social and artistic circle widened. Beardsley met Henry Harland, an American writer who also suffered from tuberculosis, in his doctor's waiting-room. At the Harlands he met Edmund Gosse and Henry James, and Aline Harland introduced him to the American painter and art-critic Joseph Pennell; at the Pennells might be found the Whistlers, or Walter Crane. And it was not long

before he found himself at The Vale, in Chelsea, where Charles Ricketts and Charles Shannon lived and worked – the one house in London, according to Wilde, where one would never be bored.

Beardsley was just twenty when he became a full-time artist, and within a year he had achieved a startling measure of public recognition. First, he produced a series of sketches for *The Pall Mall Budget*, which was edited by C. Lewis Hind, who was also planning a new monthly art magazine, *The Studio*; he had Aymer Vallance to thank for this introduction. 'Nobody gave me credit for caricature and wash-work,' Beardsley confided to Scotson-Clark, 'but I have blossomed out into both styles and already far distanced the old men.' He illustrated subjects such as the new Lyceum production of Tennyson's *Becket*, with Sir Henry Irving in the title-role – that made 'the old black-and-white duffers sit up' – and Gordon Craig in chain mail. (A wonderful caricature of Queen Victoria as a Degas dancer was suppressed.) Then, more prestigiously, he was not only approached to design the cover for the first issue of *The Studio*, which came out in April 1893, but was the subject of an article in it by Pennell, 'A New Illustrator: Aubrey Beardsley', with eight of his pictures reproduced. These included four of the *Morte Darthur* designs – valuable pre-publication publicity – the drawing 'Siegfried' (see page 106), which Beardsley had given to Burne-Jones and the ink drawing 'The Birthday of Madame Cigale', which sprang from Beardsley's new-found fantastic style. There was also a drawing of Salome with the head of John the Baptist, with the words linking it indisputably to the text of Wilde's play *Salomé*, '*J'ai baisé ta bouche, Iokanaan, j'ai baisé ta bouche.*' This was fast work, as the play had only been published on 22 February.

In his article Pennell recognized that Beardsley's work represented an unusual combination in being 'as remarkable in its execution as in its invention'; and he commented that while Beardsley's style, or rather styles, were founded on all schools, 'he has not been carried back into the fifteenth century or succumbed to the limitations of Japan; he has recognized that he is living in the last decade of the nineteenth century.' Already Beardsley was moving far beyond his immediate influences, fashioning a style that was both acutely aware of and able to quote from tradition, and yet unmistakably his own – unmistakably modern.

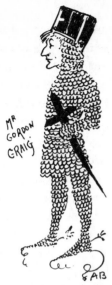

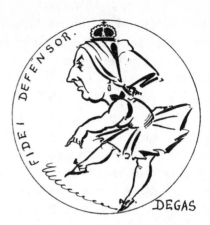

Caricature of Queen Victoria
The Queen is depicted as a
bad-tempered French ballet dancer.
Intended for publication in the
Pall Mall Budget, the drawing
was suppressed.

Edward Gordon Craig
as a Crusader
A sketch for the *Pall Mall Budget*,
9 February 1893, showing Gordon
Craig in Irving's production of
Tennyson's *Becket*.

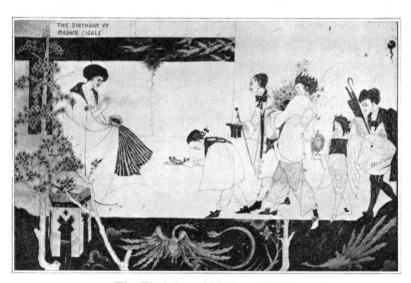

The Birthday of Madame Cigale
The line and wash drawing was published in the first issue of
The Studio, in April 1893. Beardsley, influenced by and indebted to Japanese
prints, portrays an apparent courtesan, Madame Cigale – Cicada – receiving
gifts from a procession of grotesque acolytes.

The challenge that Beardsley presented to the older generation was clearly laid down in his illustrations for *Morte Darthur*, which came out initially in parts, the first section appearing in June 1893, and then in two volumes. Beardsley's decorative borders were much stronger than the restrained, careful medievalism of Morris; and where Burne-Jones's medieval figures have a delicate, evanescent quality, which distances them, and places them centuries away from the viewer, Beardsley's figures, and his women, especially, convey an alarming immediacy, giving a contemporary feel to the ostensibly remote subject matter. Beardsley was particularly absorbed by the story of Tristram and La Belle Isoud, already re-worked by Wagner as *Tristan und Isolde*. The isolating intensity of emotion, the fatal gaze, and the closeness between love and death, were all themes that he would explore in his Salome drawings, which he was working on during the same period. The girl he pictured in 'How La Beale Isoud Wrote to Sir Tristram' might serve as a model for Wilde's Cecily Cardew writing in her diary about her engagement to Ernest.

Aymer Vallance showed the proof of one of the drawings to William Morris, who dismissed what he saw as imitation, and who, besides, repudiated the method of mechanical reproduction: 'a man ought to do his own work' was his disparaging comment. Morris's reaction got back to Beardsley, who took the implied criticism as a compliment: 'William Morris has sworn a terrible oath against me for daring to bring out a book in his manner. The truth is that, while his work is a mere imitation of the old stuff, mine is fresh and original,' he exulted to Scotson-Clark. 'I have fortune at my foot. Daily I wax greater in facility of execution. I have seven distinct styles and have won success in all of them.'

Riding the crest of the wave, he went off in triumph to Paris, not, as he announced to King, with Oscar Wilde, but on his own, though he soon met up with the Pennells. Elizabeth Pennell described his exquisitely chosen costume, a study in grey: 'grey coat, grey waistcoat, grey trousers, grey suede gloves, grey soft felt hat, grey tie which, in compliment to the French, was large and loose'. They played 'living statues' on the broken columns at St Cloud. With Pennell he went to the Opéra for a performance of *Tristan und Isolde*. Afterwards, at the Café de la Paix, they came across Whistler, who was pointedly rude to and about Beardsley. The next day at his flat

Whistler repeated this cool, off-hand behaviour, treatment that Beardsley did not forget.

On his return to London he used the sudden rush of commissions to buy a house in Pimlico, 114 Cambridge Street, where he could live with his adored sister Mabel. It was a suitable place in which to settle down to work on his next major project, the illustrations for the English version of Wilde's *Salomé*.

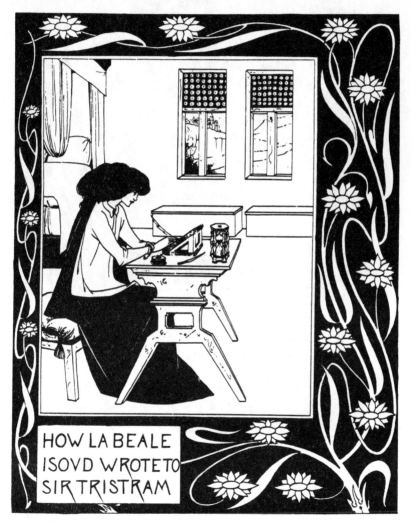

HOW LA BEALE
ISOVD WROTE TO
SIR TRISTRAM

How La Beale Isoud Wrote to Sir Tristram
An illustration to *Le Morte Darthur*, of 1892–4. The central image has the spareness of a Japanese print. The hair and profile of La Belle Isoud were to reappear in some of Beardsley's *Yellow Book* portrayals of women.

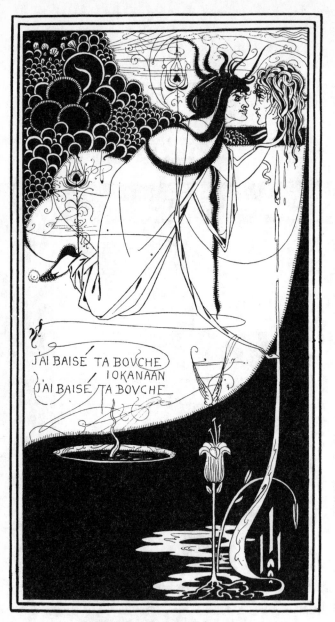

J'ai baisé ta bouche Iokanaan
The drawing of Salome was published in the
first number of *The Studio* in April 1893, prompting
the commission from John Lane to illustrate the
English edition of Wilde's play.

CHAPTER THREE

THE IMPORTANCE OF
MEETING OSCAR

OVING WITHIN THE salons and studios of the London literary and artistic world, it was inevitable that Beardsley and Wilde should meet; less certain that they might collaborate; impossible, perhaps, that there would be any easy friendship between them. But Beardsley was drawn to Wilde, as he always appeared drawn to the most significant artists and artistic events of his brief career. Recognizing that Wilde's *Salomé* represented something wholly unusual, essentially modern, ambivalent and controversial, he set out to become attached to it. His drawing for *The Studio* was, it seems, circulated before publication to carefully selected eyes, and, most probably through Robert Ross, it was shown to Wilde. Wilde duly sent Beardsley a copy of the French text, inscribed enigmatically: 'For Aubrey: for the only artist who, besides myself, knows what the dance of the seven veils is, and can see that invisible dance. Oscar.' There is a suggestion that Beardsley wanted to translate the play into English, but in the end this tricky task fell to Lord Alfred Douglas, 'Bosie', whose version so irritated Wilde that he re-worked it extensively himself. Beardsley was commissioned to provide ten full-page illustrations and a cover design for a fee of £50 by John Lane, who, together with Elkin Mathews, had founded the Bodley Head publishing house in 1892. The association with Lane was itself a signal that Beardsley had not only arrived, but had achieved recognition.

Wilde's glittering circle, in which Beardsley found himself included for a while, was a dangerous place to linger. No-one was as brilliant as Wilde; and many of its habitués were practising or covert homosexuals, like Robert Ross, Alfred Douglas, the journalist and writer Reggie Turner and the poet Lionel Johnson. The circle was in

constant flux: John Gray, for a time Wilde's close companion, and whose book of poems *Silverpoints* was financed by him, was 'rescued' from Wilde by Marc-André Raffalovich. Arthur Symons, whom Wilde would regularly meet in the saloon bar of the Crown off Charing Cross Road with Ernest Dowson, Max Beerbohm and Beardsley, was the target of Wilde's – and Beardsley's – half-humorous contempt. At the Cheshire Cheese, where the Rhymers gathered, at the Café Royal or Willis's, the conversation was sharply brilliant. 'Dear Aubrey is always too Parisian,' remarked Wilde, 'he cannot forget that he has been to Dieppe – once.' According to Frank Harris, editor, author and romancer, Wilde likened Beardsley's drawings – in his presence – to absinthe: 'It is stronger than any other spirit and brings out the subconscious self in man. It is like your drawings, Aubrey, it gets on one's nerves and is cruel.'

Wilde's most comfortable relationships were usually with people who did not compete directly with him. Beardsley's genius challenged Wilde's, while his sexuality remained mysterious. The literary critic Ian Fletcher described Beardsley's sexual tastes as 'either muted or equivocal', and there is no direct evidence that he was homosexual (although he was, clearly, deeply interested in sexuality in all its forms). Wilde was puzzled, and unusually waspish towards someone with whom he was so intimate: 'don't sit on the same chair as Aubrey,' he once said, 'it is not compromising'. The painter William Rothenstein recalled Beardsley at this time, with his:

> butterfly ties, his too smart clothes with their
> hard, padded shoulders, his face – as Oscar said –
> 'like a silver hatchet' under his spreading chestnut
> hair, parted in the middle and arranged low over
> his forehead, his staccato voice and jumpy, restless
> manners.

He seemed a 'portent of change'.

His involvement with *Salome*, the English version of Wilde's play, placed Beardsley at the centre of the Decadent Movement. Wilde's text was already controversial, and confrontational. He had written it originally in French, a signal of his intention to be modern as well as a tribute to another culture. Then he decided to have it staged in

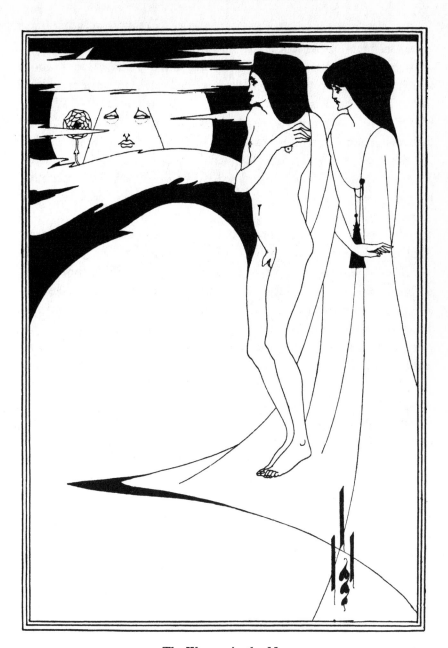

The Woman in the Moon
The frontispiece to Wilde's *Salome*, published
in 1894, is an illustration to the first scene, in
which the Page of Herodias and the young Syrian
Captain, Narraboth, gaze at the moon. Wilde's
features are suggested in the moon.

London, in French, with Sarah Bernhardt in the title-role. The visual aspects were endlessly discussed. Charles Ricketts was brought in to design the settings and suggested 'a black floor – upon which Salome's white feet would show'. Salome's costume might be black, like the night, or silver, like the moon, or – Wilde's contribution – 'green like a curious poisonous lizard'. Graham Robertson joined in, and came up with the idea of a violet sky. He designed a golden robe for Bernhardt, with a triple crown of gold and jewels – 'and the cloud of hair flowing from beneath it was powdered blue'. But all these exotic concepts were to come to nothing.

Rehearsals started in June 1892, and after two weeks it became clear that the play would be refused a licence, technically under the law forbidding the depiction of Biblical characters. Wilde threatened to leave England and settle in France, where he would take out letters of naturalization: 'I will not consent to call myself a citizen of a country that shows such narrowness in artistic judgement. I am not English. I am Irish which is quite another thing.' The play was published in Paris in February 1893. Elkin Mathews and John Lane distributed the edition in London, and Wilde showered his friends with copies. It was at this point that Wilde chose Beardsley to illustrate the English edition, rather than Ricketts, who had designed *Silverpoints* and was working on *The Sphinx*.

For a while, relations between author and illustrator remained calm. Max Beerbohm attended the last night of *A Woman of No Importance* on 16 August 1893 at the Haymarket Theatre, where he saw Oscar with 'Bosie and Robbie and Aubrey Beardsley. The last of these had forgotten to put vineleaves in his hair, but the other three wore rich clusters – especially poor Robbie.' Already Beardsley was unconsciously distancing himself from Wilde's lifestyle, if not his art.

Beardsley's accounts of his own social life seem more designed to entertain or startle than anything else. 'I hope that William Rothenstein has done no more than take you to the Chat Noir in the daytime and shown you the outside of the Moulin Rouge,' he wrote to Lane, who was in Paris, adding that he was going to the St James's Restaurant on Thursday night 'dressed up as a tart and mean to have a regular spree'. But in another letter to Rothenstein he mentioned 'severe attacks of blood spitting', which made it impossible for him

to travel to Paris – he would be 'funky of the sea' in that condition, and so would remain at home.

His family was by now established in Cambridge Street, the nearest thing Beardsley ever experienced to a permanent home. Aymer Vallance undertook the decorations. The walls were distempered a violent orange, the doors and skirtings were painted black – a strange taste, commented Will Rothenstein, adding that his friend's taste was 'all for the bizarre and exotic'; in choosing orange Beardsley was following the preference of Des Esseintes, hero of Huysmans's novel *A rebours*. Like Des Esseintes, Beardsley was interested in the effect of candlelight – and it was by candlelight, with the curtains drawn against the daylight, that he usually worked. Rothenstein gave him a Japanese Book of Love, and was rather shocked when he next went to see him that he had taken out the most indecent prints and hung them in his bedroom. 'Seeing he lived with his mother and sister, I was rather taken aback.' Beardsley generously invited Rothenstein to make use of his workroom whenever he was in London, where the two sat on either side of a large table.

> He would indicate his preparatory design in
> pencil, defining his complicated patterns with only
> the vaguest pencil indications underneath, over
> which he drew with the pen with astonishing
> certainty. He would talk and work at the same
> time for, like all gifted people, he had exceptional
> powers of concentration.

Beardsley worked on the *Salome* illustrations from the summer of 1893. 'If you happen to be near Elkin Mathews *today*,' he wrote to Ross in June, 'they have a drawing [Salome] to show you'; and in August he told him that '*Salome* goes famously. I have done two more since I saw you; one of them, the *Studio* picture redrawn and immensely improved.' Then he began to run into difficulties.

He was very ill for a spell. More importantly, the *Salome* drawings had created 'a veritable fronde,' he informed Will Rothenstein, 'with George Moore at the head of the frondeurs'. There were two sets of problems. First, Wilde was dismissive of

Enter Herodias
In a later version of the
illustration to Wilde's *Salome*
Beardsley added a fig-leaf to
the attendant youth, who is
unaroused by the dominant
Herodias, unlike the grotesque
foetus who fingers her robe
(a feature that presumably
passed Lane by). Wilde,
with witch-doctor's cap and
jester's bells, presents the
scene like a prompter or
master of ceremonies.

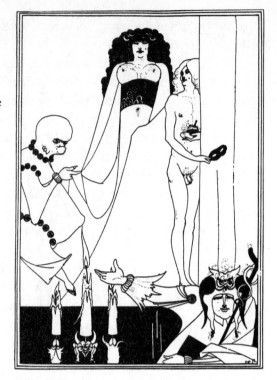

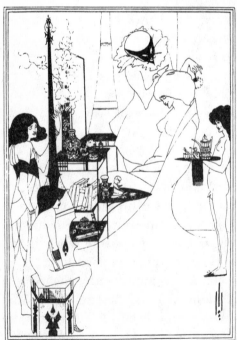

The Toilet of Salome
This is Beardsley's first version
of the illustration to *Salome*, in
which the half-naked Salome
sits among furniture in the
Japanese taste. Lane and
Mathews rejected a version in
which at least two of the figures
seem intent on pleasuring
themselves. French novels and
an ornamental foetus decorate
this decadent tea-ceremony.

Douglas's translation, and eventually rewrote it himself, which delayed publication. Rather more seriously for Beardsley, Lane rejected a number of Beardsley's drawings, or forced him to revise and expurgate them. 'I can tell you I had a warm time of it between Lane and Oscar and Co.,' Beardsley complained to Ross. 'For one week the number of telegraph and messenger boys who came to the door was simply scandalous.'

Beardsley was proving a far harder artist for Lane to handle than Wilde. Although Beardsley's first drawing, 'J'ai baisé ta bouche Iokanaan', depicted the shockingly violent climax of the play, it had a decorative quality that slightly softened, or distanced, the subject matter. By the time the drawings were complete, Beardsley's style had altered, and the full vigour and starkness of his mastery of line, and of black and white, were displayed unambiguously. In the very first drawing, 'The Woman in the Moon', the figure of the page was depicted naked, Herodias was bare-breasted, as was Salome in two of the other illustrations, and Herodias's attendant was also naked. This was all too much for Lane, who began to demand changes, though with bewildering inconsistency. Genitalia, and Salome's navel, and the youth's pubic hair, were all frowned on, and Beardsley was instructed to conceal the offending parts or produce alternative drawings. The page escaped – perhaps Lane thought a penis acceptable in the presence of another male figure – but Herodias's attendant had to be covered up with a fig leaf. Beardsley sent a copy of the proof to a friend, adding the words:

> Because one figure was undressed
> This little drawing was suppressed
> It was unkind –
> But never mind
> Perhaps it all was for the best.

Lane overlooked the phallic candles, and the erection beneath the clothing of the grotesque dwarf holding Herodias's robe. Out went the first version of 'The Toilet of Salome' (with the genitalia and pubic hair), and the replacement substituted Zola's *Nana* for *La Terre* among the scandalous books displayed on the dressing-table, while a volume labelled 'Marquis de Sade' was defiantly added.

41

Beardsley pushed against the boundaries of discretion, if not of good taste, by deciding to include no fewer than four caricatures of Wilde in the illustrations. One was the satanic master of ceremonies whose gesture points to the dwarf's aroused condition; the other three were incorporated within the face of the moon, in 'The Woman in the Moon' and again in 'A Platonic Lament', and in the figure of Herod in 'The Eyes of Herod'. Beardsley was buoyant and unrepentant. 'I have withdrawn three of the illustrations and supplied their places with three new ones (simply beautiful and quite irrelevant),' he wrote to Ross, adding, indiscreetly, on the subject of Douglas and Wilde, 'Both of them are really very dreadful people.' When *Salome* was published, in February 1894, the description of Beardsley's contribution was 'pictured by Aubrey Beardsley': a subtle but accurate definition.

Wilde and Beardsley at least agreed with each other on the blue boards that Lane chose for the cover. Wilde dismissed them as 'coarse and common' – 'I loathe it. So does Beardsley.' Lane relented for the *édition de luxe*, and Beardsley's peacock-feather design was executed in green silk and stamped in gold.

Beardsley's work on *Salome* was extraordinary. Most early commentators assumed that there was something slightly mocking in the tone and style of his pictures, perhaps seizing on the elements of caricature, or the apparent remoteness of some of the designs from the play's text – 'The Toilet of Salome', in its revised version, has only a tenuous connection with Salome's preparation for the dance before Herod, for example. 'Mr Aubrey Beardsley is a very clever young man, but we cannot think his cleverness is quite agreeable to Mr Wilde. Illustration by means of derisive parody of Félicien Rops, embroidered on to Japanese themes, is a new form of literary torture,' commented *The Saturday Review*. Apropos 'The Toilet of Salome', it was no wonder that her conversation had an irreligious effect upon the Tetrarch; 'But what a fantastic way of illustrating a Biblical tragedy!' *The Times* was harsher, seeing the illustrations as 'fantastic, grotesque, unintelligible for the most part, and, so far as they are intelligible, repulsive'; the whole thing 'must be a joke, and it seems to us a very poor joke!'

Beardsley had clearly burrowed some distance beneath the thin English skin, in the very sensitive area of sexuality. In fact, the

subjects and moments in the play that he chose to illustrate reveal an acute understanding of the unusual nature of the piece. It took about a hundred years for this to be recognized, and achieved in a stage performance – except when transmitted through Richard Strauss's opera based on the play. The importance of the gazing moon, and the idea of its accompanying danger, is established in Beardsley's frontispiece; the corrupt sensuality of Herodias; the conflict between Salome and Herod with his 'mole's eyes'; and the seizing of Iokanaan's head by Salome: all form crucial elements in the way the play works on stage. At the time, the Censor's intervention prevented an English performance, in any language.

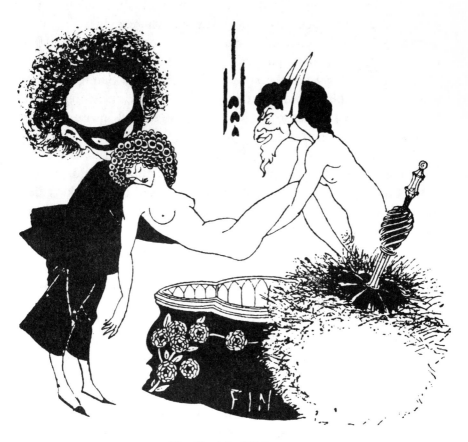

The Burial of Salome
The *cul-de-lampe*, or tailpiece, to *Salome*. Wilde
admired the *Salome* illustrations but felt that Beardsley
had misinterpreted the tone of the play.

Beardsley supplied his own visual commentary, which both brought out something of the play's dramatic qualities, and at the same time hinted at and suggested other levels and meanings. It was impossible to look at Beardsley's drawings and be deceived that Wilde had written a Biblical or a historical drama. Beardsley gave the text its first true public and modern performance, placing it firmly in the eighteen-nineties – a disturbing framework for the dark elements of cruelty and eroticism, and of the deliberate ambiguity and blurring of gender, which he released from Wilde's play as though he were opening Pandora's box.

Wilde's attitude to the drawings was, predictably, ambivalent. He admired them, thought them 'quite wonderful', but did not like them, describing them as too Japanese, whereas his play was 'Byzantine'. To Ricketts, he declared that 'My Herod is like the Herod of Gustave Moreau, wrapped in his jewels and sorrows. My Salome is a mystic, the sister of Salammbo, a Sainte Thérèse who worships the moon.' Certainly, the influence of Moreau and Flaubert infused Wilde's work; Beardsley shifted it into other contexts and perspectives.

According to Rothenstein, Beardsley was relieved to finish his *Salome* drawings: 'The inspiration of Morris and Burne-Jones was waning fast, and the eighteenth-century illustrators were taking the place of the Japanese print.' He was already moving swiftly on in terms of style and technique.

By the time *Salome* was published, Beardsley was deeply involved in a new project, *The Yellow Book*. This new literary and artistic quarterly was conceived by Beardsley and Henry Harland, and it was to be deliberately got up to look like a French novel. There were to be short stories and essays by writers such as Harland, Henry James and Max Beerbohm, and drawings by Beardsley, Walter Sickert, Philip Wilson Steer and Will Rothenstein. Beardsley was to be the art editor, and John Lane would publish it. 'Our idea,' explained Beardsley to Ross, 'is that many brilliant story painters and picture writers cannot get their best stuff accepted in the conventional magazine, either because they are not topical or perhaps a little risqué.' Ross never contributed, but Beardsley was eager to fire his friends with his enthusiasm. Max Beerbohm much later dramatized the magazine's conception. It was to be, 'Not a

thing like the *Edinburgh* or the *Quarterly*. Not just a *paper* thing. A *bound* thing: a real <u>book</u>, bound in good thick boards. *Yellow* ones. Bright yellow. And it's going to be called *The Yellow <u>Book</u>*.' The point, Beerbohm explained, was that Aubrey's accent was on '*<u>Book</u>*'. Although the colour, perhaps the defining colour of the decade, was important to him, the main thing was that it was a book, something to last longer than a quarter of a year.

According to Harland, the genesis was on New Year's Day 1894. After meeting at their doctor's, the two lunched on a day of 'one of the densest and soupiest and yellowest of all London's infernalest yellow fogs', and shared their outrage about London publishers until they resolved to have a magazine of their own. 'As the sole editorial staff we would feel free and welcome to publish any and all of ourselves that nobody else could be hired to print.' They may well have been continuing conversations that had started the previous summer at Sainte Marguerite, a seaside village in Normandy where Aubrey and Mabel had joined the Harlands, the painter Charles Conder, the critic D. S. MacColl, and others, in a kind of Arcadian idyll, sitting 'in a vine-covered tunnel or at a table on the lawn' and where 'in the rosy darkness the beds of white and violet petunias' smouldered. The yellow fogs of London would seem a more fitting setting, however.

If Beardsley sought to shock, Harland was more conservative, and the two worked closely together to produce a blend of the avant-garde and the more widely acceptable. Perhaps to avoid notoriety, Wilde was not invited to contribute, though he was happy enough to introduce Beardsley to Mrs Patrick Campbell. She was playing the title-role in Pinero's *The Second Mrs Tanqueray* at the St James's Theatre. Wilde sent her a note from the box he was sharing with Beardsley – 'with your gracious sanction, I will come round after Act III with him … He has just illustrated my play of *Salome* for me, and has a copy of the edition de luxe which he wishes to lay at your feet.' She granted Beardsley a sitting, and the drawing duly appeared in the first number.

By this point Wilde's attitude had hardened. One day, in the domino room of the Café Royal, Beardsley had shown Wilde the design for the magazine's cover. Max Beerbohm asked what it was like. 'Oh,' said Oscar, 'you can imagine the sort of thing. A terrible

naked harlot smiling through a mask – and with Elkin Mathews written on one breast and John Lane on the other.' 'Dull and loathsome' was his sour verdict to Douglas on the first number, 'a great failure. I am so glad.'

Beardsley was in no mood for compromise or tact. His drawing for the prospectus of *The Yellow Book*, with Elkin Mathews as an elderly pierrot in the door of a bookshop rather like the Bodley Head, where a tall, elegant, but slightly sinister figure, a New Woman of the night streets, is about to select an item, was witty and restrained. One of his drawings for the first number, however, called 'A Fat Woman', was unmistakably a likeness of Mrs Whistler. Beardsley wrote that he would assuredly commit suicide if it did not appear. 'I shouldn't press the matter a second if I thought it would give offence,' he continued, tongue in cheek – and suggested, just to make the Whistler connection crystal clear, that it should be called 'A Study in Major Lines'. (Lane was adamant about not including the drawing, and Beardsley managed to place it in *To-Day*.)

Although most of the contents of the first number were unexceptionable – they included a story by Henry James and drawings by the President of the Royal Academy, Sir Frederick Leighton, to signify quality and respectability – there was also a light and frivolous Max Beerbohm essay, 'A Defence of Cosmetics', a poem by Arthur Symons, which seemed to refer to a meeting with a prostitute, and quite enough of Beardsley's work to provoke the critical establishment.

John Lane made the most of the launch, celebrating *The Yellow Book*'s publication with a dinner in the private dining-room of the Hotel d'Italia in Old Compton Street, in Soho. Beardsley and Henry Harland sat at the high table, flanking Elizabeth Pennell. Max Beerbohm, the playwright John Davidson, Ernest Dowson, the writer Kenneth Grahame, Lionel Johnson, George Moore, Walter Sickert and W. B. Yeats were present, contributors, prospective contributors and enthusiasts. Speeches and toasts abounded. Beardsley began, in an echo of Wilde, 'I am going to talk about a most interesting subject – myself.' At the end of the dinner Lane took a select few, including Beardsley, to his Vigo Street office, and then on to the Monico, an extended celebration that he kept quiet from his partner Mathews. *The Yellow Book* was Lane's personal

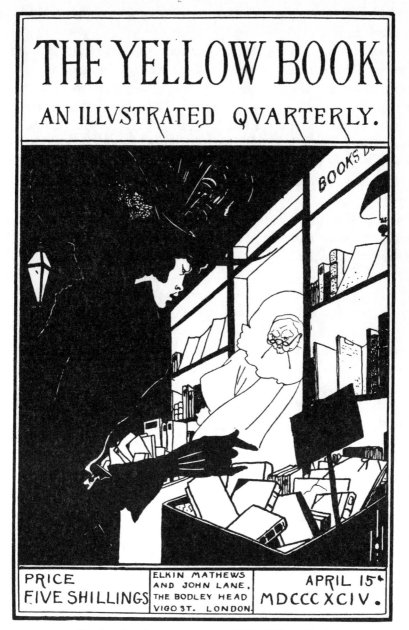

Design for the prospectus of *The Yellow Book*
The expensively dressed woman is on a night book-buying expedition,
and the elderly pierrot – perhaps Elkin Mathews – watches quizzically
as she chooses her reading from the Vigo Street bookshop. The strange
gesture of the black-gloved hand reaching out like a talon, and the
woman's parted lips, suggest keen anticipation.

project, and he took it with him when he split from Mathews later in the year.

Aesthetically, Beardsley's contribution dominated the first volume. He provided the cover, and the verso of the cover, as well as the design for the title-page – a woman playing the piano in a meadow – and three other drawings: 'L'Education Sentimentale', 'Night Piece' and the profile portrait of Mrs Patrick Campbell. Symons's poem and Beerbohm's essay attracted some hostility, being thought immoral or trivial. But it was the look of the whole publication that set the tone; and the look was Beardsley's.

If the critics were not wholly sure what Beardsley's style and content meant, they sensed that it was intended to be provocative, decadent and subversive. *Punch*, relentlessly conservative, targeted the appearance:

> LEAVES – like Autumn leaves – the tint of custard,
> Cover like a poultice made of custard,
> General aspect bilious.
> But, ye gods, the things called 'illustrations'!
> Ill-drawn, objectless abominations!
> Supernatural silliness.

The *Westminster Gazette* went further. Prefacing its judgement with praise of Beardsley's undoubted skill as a line draughtsman, and his capability for 'refined and delicate work', it continued:

> But as regards certain of his inventions in this
> number, especially the thing called 'The
> Sentimental Education', and that other thing to
> which the name of Mrs Patrick Campbell has
> somehow become attached, we do not know that
> anything would meet the case except a short Act
> of Parliament to make this kind of thing illegal.

It was Beardsley's way of representing women that generally attracted most outrage. *The World* complained bitterly about the Mrs Patrick Campbell portrait, and its 'black sticking-plaister hat, hunchy shoulders, a happily impossible waist, and a yard and a half

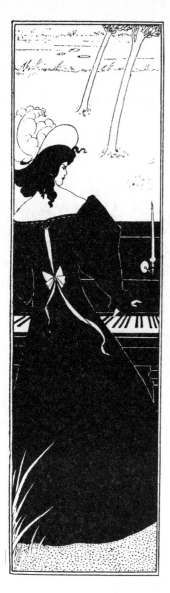

Design for the title page of
The Yellow Book
The design was for the first issue, of April 1894. Beardsley defended the subject by citing a fictitious authority who recorded that Gluck composed three of his operas in a field, with his piano before him and a bottle of champagne on either side.

Portrait of Mrs Patrick Campbell
The actress is shown in the role of Paula Tanqueray, a woman with several pasts, in Pinero's controversial *The Second Mrs Tanqueray*. Many reviewers disparaged this and other Beardsley 'portraits' of actresses as 'hideous caricatures'.

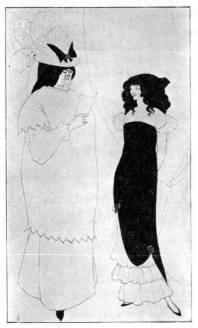

L'Education Sentimentale
Illustrated in Volume I of *The Yellow Book*, this picture, with its glance at Flaubert's novel, aroused strong reactions. Whether interpreted as an elderly whore instructing a novice, like a high priestess of vice, or a governess and her pupil – a decadent version perhaps of Wilde's Mis Prism and Cecily Cardew – there is a distinct whiff of corruption.

A Night Piece
There are low-life connotations in the title and the London setting, together with the scandalous associations of the Arthur Symons poem 'Stella Maris' that followed in *The Yellow Book*.

50

of indefinite skirt'. The reviewer from W. E. Henley's *National Observer* wrote that Beardsley's women resembled:

> nothing on the earth, nor in the firmament that is
> above the earth, nor in the water under the earth
> with their lips of a more than Hottentot thickness,
> their bodies of a lath-like flatness, their impossibly
> pointed toes and fingers, and their small eyes
> which have the form and comeliness of an
> unshelled snail.

But while the critics condemned the style and manner of the illustrations, or described the lady playing a piano in the middle of a field as 'unpardonable affectation', they were more probably recoiling at the possible interpretations of the 'thing' called 'L'Education Sentimentale'. Max Beerbohm described it to Reggie Turner:

> A fat elderly whore in a dressing-gown and huge
> hat of many feathers is reading from a book to the
> sweetest imaginable little young girl, who looks
> before her, with hands clasped behind her back,
> roguishly winking. Such a strange curved attitude,
> and she wears a long pinafore of black silk, quite
> tight, with the frills of a petticoat showing at
> ankles and shoulders: awfully like Ada Reeve, that
> clever malapert, is her face – you must see it. It
> haunts me.

These images of women terrified the critics: 'L'Education Sentimentale', with its glance at Flaubert's novel, suggests both the corrupting power of the matriarch, madame or governess, and the equally corrupt knowingness of a seemingly innocent ingénue. What is the old woman reading? A French novel, perhaps, by Flaubert, Huysmans or Zola, a poison book such as Lord Henry Wotton gave to Wilde's Dorian Gray. Beardsley's other drawing, 'A Night Piece', was equally suggestive, presenting a well-dressed lady of the night, the figure elongated as in the study of Mrs Patrick Campbell, against a city background that is presumably London; the word 'Costumes'

suggests the theatre district, while Symons's poem, 'Stella Maris', follows, to indicate guilt by association. The role that Mrs Campbell was playing, Paula Tanqueray, was that of a woman with a past, several pasts, now married but still not acceptable in polite society.

These images of women, erotic, powerful, independent and, above all, obviously inhabitants of modern London, challenged accepted versions of art and society. *The Academy* labelled Beardsley's drawings 'meaningless and unhealthy'; *The Times* spoke of the 'repulsiveness and insolence' of the cover, and described the overall artistic note as 'a combination of English rowdyism with French lubricity'.

It was all good for sales. The first run sold out within a week, a second edition followed, and a third was printed the following weekend. *Punch* pronounced, 'Uncleanliness is next to Bodliness.' Some of the contributors began to run for cover. Leighton called round to tell Lane he had promised his friends not to appear again in such company. Henry James confessed to his brother that, although his own tale had had an unusual success, he hated 'the horrid aspect and company of the whole publication'. But he still allowed Beardsley to reproduce Sargent's drawing of him in the second number. 'Have you heard of the storm that raged over No. 1?' Beardsley enquired. 'Most of the thunderbolts fell on my head. However I enjoyed the excitement immensely.'

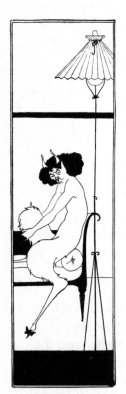

The Dancing Faun
Cover design for Florence Farr's Keynotes novel of 1894.

Beardsley, like Wilde, tended to meet his critics more than half way, and he fired off a letter to *The Daily Chronicle*, whose reviewer had complained that the portrait of Mrs Patrick Campbell was missing from his copy. For once, though, Beardsley did not get the best of the exchange. From the newspaper came back the reply, 'Our own copy, it is true, contained a female figure in the space thus described, but we rated Mrs Patrick Campbell's appearance and Mr Beardsley's talent far too high to suppose that they were united on this occasion.'

Beardsley was in great demand, almost overwhelmed by the variety of commissions which came his way in addition to the work involved in editing, and contributing to, the succeeding numbers of *The Yellow Book*. The distinctiveness of his line, and his ability to design work for mechanical reproduction, had already led him into the field of the poster. He had seen the work of Toulouse-Lautrec, Alphonse Mucha and Jules Chéret in Paris, and later wrote an essay expanding on the new art form:

> Advertisement is an absolute necessity of modern life, and if it can be made beautiful as well as obvious, so much the better for the makers of soap and the public who are likely to wash ...
> Now the poster first of all justifies its existence on the grounds of utility, and should it further aspire to beauty of line and colour, may not our hoardings claim kinship with the galleries ... ?

Florence Farr, actress, author and producer, commissioned Beardsley to design the programme for John Todhunter's *A Comedy of Sighs*, which she was to present at the Avenue Theatre in March 1894, together with W. B. Yeats's *The Land of Heart's Desire*. 'I think you will find dark green on light the most satisfactory scheme of colour,' Beardsley advised her. 'By the way, if my design is going to be used as a poster had I not better draw it large size and have it reduced for the programme?' The Avenue Theatre design, daring in its simplicity, was printed in blue and green, and was indeed used for both the programme and the poster.

Beardsley went with Max Beerbohm to the opening, to see the curtain raiser, Yeats's 'beautiful little play', acted in 'nerveless and inaudible manner'. *A Comedy of Sighs* that followed was a fiasco, however, and George Bernard Shaw was summoned to supply a new play to replace it. He suggested *Widower's Houses*, but that would clearly not do. He produced the manuscript of *Arms and the Man*, sat down in Embankment Gardens to put the finishing touches to it and dropped it off at the typewriting agency. Beardsley's design now served for *Arms and the Man*, or, as *Punch* described it, 'Shoulders and the Woman'.

Beardsley's poster may have been the first theatrical poster to receive reviews: *The Globe* called it 'an ingenious piece of arrangement, attractive by its novelty and cleverly imagined. The mysterious female who looms vaguely through the transparent curtain is, however, unnecessarily repulsive in facial type ... ' The tea-heiress Annie Horniman, who was financing the Avenue Theatre season, commented that 'even the cab horses shied' when they passed the image. Was she, horror of horrors, a New Woman? William Archer, reviewing *A Comedy of Sighs*, wrote that the intention 'seems to have been to get the scent of *Keynotes* over the footlights': *Keynotes* was an 'advanced novel' by George Egerton as well as the title of John Lane's series, which had covers designed by Beardsley. Beardsley's poster offered a strong, brooding, even aggressive woman to the public eye. Owen Seaman parodied Tennyson in *Punch*:

> Mr Aubrey Beer de Beers,
> You're getting quite a high renown;
> Your Comedy of Leers, you know,
> Is posted all about the town;
> This sort of stuff I cannot puff,
> As Boston says, it makes me 'tired';
> Your Japanee-Rossetti girl
> Is not a thing to be desired.

Beardsley went to the first night of *Arms and the Man*, along with Will Rothenstein and most of intellectual, artistic and theatrical London, including Wilde, George Moore and Yeats. (The Duke of Edinburgh, according to Yeats, appalled by Shaw's treatment of military heroism, could be heard muttering in his box, 'The man is mad, the man is mad.')

It is surely no accident that Beardsley, with his instinctive feeling for the theatrical as well as for the artistically significant, should be associated with the three great Irish dramatists of the moment, Wilde, Yeats and Shaw. With *Salome* Beardsley took the art of illustration into new territory. With the poster for Florence Farr's season, his first attempt in a new form, he placed his style and his personality startlingly and unerringly in the public eye.

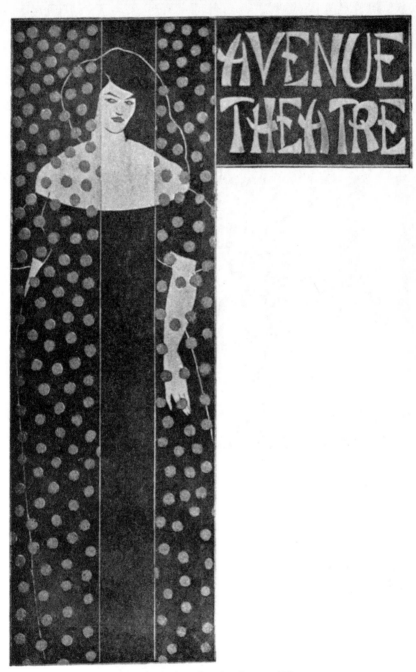

Poster design for the Avenue Theatre
Showing a New Woman, the design was used
for both *The Comedy of Sighs* and its replacement,
Arms and the Man.

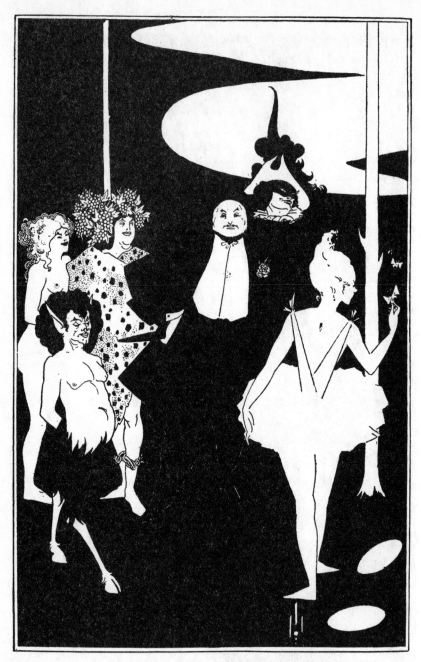

Frontispiece to John Davidson's *Plays*
The book was published by Elkin Mathews and
John Lane in 1894. The centre figure has been identified
as the theatre impresario Sir Augustus Harris, the figure
with vine-leaves in his hair and bound feet as Wilde
and the faun as Henry Harland.

THE COLOUR OF DECADENCE

B Y THE SPRING OF 1894 Beardsley was famous – or perhaps infamous. He was extremely busy as an artist. There were the next numbers of *The Yellow Book* to prepare, including his own significant contributions. He was commissioned to produce a poster for Singer sewing machines, and he wittily adapted his mischievous image of a woman playing a piano in a field. Maurice Baring, an undergraduate at Trinity College, Cambridge, wrote and asked him to design a cover for a new magazine, *The Cambridge ABC*: Beardsley accepted, for ten guineas. He designed book-plates, a drawing for a calendar and a pen-and-ink design for a ladies' golf club. There were illustrations for John Lane's publications, including a notorious frontispiece for John Davidson's *Plays*. Edmund Gosse urged him to change direction and concentrate on illustrating classic literature, such as *The Way of the World*, *Volpone* and *The Rape of the Lock*. Beardsley at first could see only the attraction of *The Way of the World*, though eventually he would produce exceptionally brilliant work for the other books suggested by Gosse. He was also working for an American publisher, who had written with a proposal that he should provide some illustrations for Edgar Allan Poe's *Tales of Mystery and Imagination*.

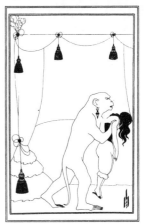

The Murders in the Rue Morgue
An illustration to Poe's story in which the murderer is as an orang-outang.

Beardsley was simultaneously leading a very active and public social life. He and his sister entertained regularly. In the evenings

he went out, to the theatre and the opera, to the Alhambra and Empire music-halls, and the Café Royal; and he was seen at concerts and smart luncheons and garden parties. Robert Ross described him as gregarious and sociable, someone who never pretended to be busy: 'He never denied his door to callers, nor refused to go anywhere on the plea of "work."'

To a large extent these London evenings were work, as he noted down subjects for future, or immediate, use. He had to go and see the French actress Madame Réjane in *Madame Sans-Gêne*, by Victorien Sardou and Gustave Moreau, as he had just drawn a new portrait of her for the second volume of *The Yellow Book*. (It did not provoke the same outrage as the 'portrait' of Mrs Patrick Campbell, except, reportedly, from Madame Réjane herself, who wept and screamed.) He made sure he attended every production of the Wagner season at Drury Lane – in June 1894, he saw both *Tristan und Isolde* and *Tannhäuser*, and after the latter he conceived 'a big long thing of the revels in act 1 which would simply astonish everyone': this would be his 'romantic novel' *The Story of Venus and Tannhäuser*, which was later published as *Under the Hill*, the prose work he continued to work on and illustrate until the end of his life. His letters of 1894 are full of this project, though the publication date always receded. The opera house, perhaps, was his favourite place, and he would happily sit and talk with Mabel and other friends on the Gallery stairs.

The drawings of 1894, many of which found their way into *The Yellow Book*, offer, quite apart from their technical brilliance, a disconcerting commentary on English social life. 'Lady Gold's Escort' shows a diminutive, elderly woman emerging from her carriage, at the entrance to what is presumably – from the clue of three letters – The Lyceum Theatre, Sir Henry Irving's temple of drama. The massed black, and the bloated, brutal figures and cruel expressions of the onlookers, offer a raw comment on the true values of consumer society, as they stand around with all the 'delicate fopperies of fashion', gloves and canes, ostrich feathers and top hats, huge muffs and, a bizarre image of coquetry for Lady Gold, a fan. 'The Wagnerites', according to Pennell, was inspired by an evening at the Paris Opéra: again, there is the stunning use of black, white being reserved largely for the faces and backs and bosoms of the

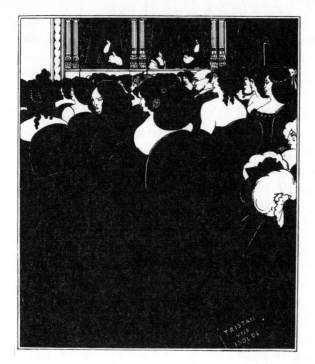

The Wagnerites
The drawing, reproduced in *The Yellow Book*, Volume III, October 1894, was inspired by a performance of *Tristan und Isolde* at the Paris Opéra. The women dominate, and their aggression is in ironic counterpoint to the tragic love-story of the opera.

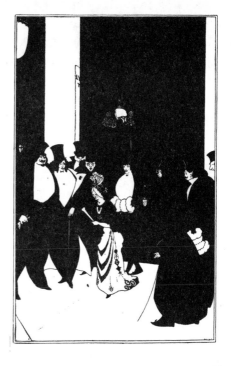

Lady Gold's Escort
This menacing night piece, reproduced in the same issue of *The Yellow Book*, is set outside Irving's Lyceum Theatre. The looming, gross dandies, all dress and accessories, who surround the old woman, seem likely to be more interested in money than the arts.

coarse-expressioned audience, all female except one bald-headed and timid-looking male. The brooding power and wealth, and the aggressive indifference generated in the image of the spectators, conflict sharply with the work they have come to see, Wagner's most romantic and idealistic opera, *Tristan und Isolde*.

The idea of the theatre, and of the mask and the masquerade, form the strongest common theme in all Beardsley's work for *The Yellow Book*, from the masks of the cover design for Volume I onwards. Volume II contains three designs called 'The Comedy Ballet of Marionettes'. Volume III was more controversial, for it includes John Davidson's 'The Ballad of a Nun', another Arthur Symons hymn to the night and a provocative essay by Max Beerbohm, 'A Note on George the Fourth'. Beardsley contributed, besides 'Lady Gold's Escort' and 'The Wagnerites', a fanciful portrait of himself, a small figure dwarfed in a huge eighteenth-century bed. He also slipped in two 'spoof' portraits – one of Mantegna, by 'Philip Broughton', and a study of a woman, by 'Albert Foschter' – and was delighted at his invention when these drawings had 'rather a success with the reviewers'. One of these, according to Beerbohm, 'advised Beardsley "to study and profit by the sound and scholarly draughtsmanship of which Mr Philip Broughton furnishes another example of his familiar manner"'. Beardsley sold the 'Broughton' to Shaw.

This frenetic pace could not be kept up. In August his mother persuaded Beardsley to leave London for the quieter surroundings and healthier climate of Haslemere. 'Down here all is too peaceful for my restless brain,' he complained to Evans, thanking him for some photographic portraits. He was absorbed in his *Tannhäuser* book – and at least Haslemere offered 'the pick of scenery' and was full of possible backgrounds. But he simply longed for London, 'the only place where you can live, or work (which comes to the same thing)'. Mrs Beardsley persuaded her son to stay on from day to day, but, she told Ross, 'his depression was so great and the life he led me so dreadful that at the end of a fortnight I gave it up and let him come home'. Back in town, he went on with his editorial work for *The Yellow Book*, and offered an account of his life to the editor of Hazell's *Annual*, with the laconic preface, 'Next year you will I am sure be able to announce my death in addition to other events of my

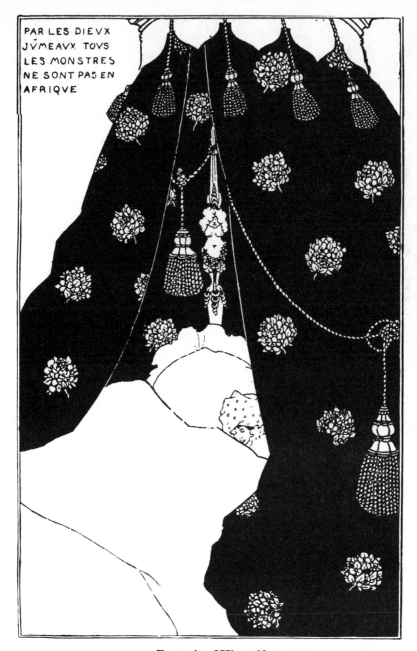

PAR LES DIEVX
JVMEAVX. TOVS
LES MONSTRES
NE SONT PAS EN
AFRIQVE

Portrait of Himself
'By the twin gods not all monsters are in Africa'.
Beardsley did not spare himself in this portrait of the artist
as a small creature in a vast, canopied bed, accompanied
by an attendant satyress on the bed-post.

61

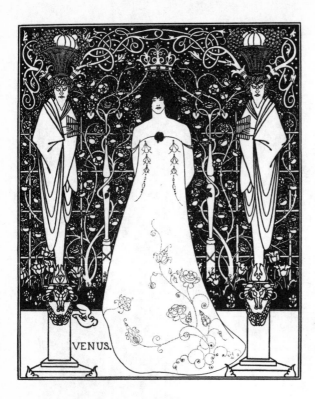

Venus Between Terminal Gods
A frontispiece intended for a version of the Tannhäuser legend, an uncompleted and unpublished project. Venus promises pleasure, the gods deny it.

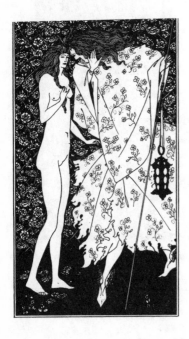

The Mysterious Rose Garden
Described by Aymer Vallance as a 'burlesque Annunciation', Beardsley claimed that it was the first of a series of Biblical illustrations, though it seems to represent a pagan sexual initiation.

life.' He was suffering from acute haemorrhaging of the lungs, and in November left London again for Malvern, to stay in a clinic. His mother saw him off at Paddington station, sitting opposite Dr Grindrod in a third-class railway carriage, 'looking like a little white mouse caught in a trap'. In Malvern, scene of suffering for so many Victorians, he sat about moping all day in the hydropathic establishment, worrying about his 'beloved Venusberg'. He confided to Evans, 'I can think of nothing else. I am just doing a picture of Venus feeding her pet unicorns which have garlands of roses round their necks.'

In December he was staying in the Lake District at Windermere, as a guest of John Lane. The house party included Max Beerbohm and, ironically in view of future events, the poet William Watson. Lane commented later that:

> After myself, Aubrey was the best behaved of the
> party. He attended church services regularly and
> devoutly, and as long as he lived the rector never
> failed to make inquiries about 'that devout youth'.

Probably over this holiday Lane and Beardsley discussed a possible trip to the United States. Lane was planning to go to New York and Boston. Max Beerbohm was due there soon as well, acting as private secretary to his half-brother Herbert Beerbohm Tree during his company's American theatre tour. Beardsley was definitely planning a trip that spring, perhaps even to give a series of lectures, as Wilde had done in the 1880s. 'Most amazing biographies are being published of me in American papers just now,' he wrote to the writer Ada Leverson.

Back in London at the beginning of 1895, Beardsley took up his social life again. There were two glittering Oscar Wilde premières to attend: *An Ideal Husband,* on 3 January, when he sat with Mrs Leverson, Wilde's 'Sphinx', in her box; and again at the St James's Theatre on Valentine's Day, once more as Ada Leverson's guest, at the first night of *The Importance of Being Earnest.* This time Mabel joined them – her career as an actress had been launched in the role of Lady Stutfield in the touring production of *A Woman of No Importance.* Wilde stayed in the wings until after the second act,

when he visited the Leversons' box. He teased Beardsley, calling Mabel a daisy and Aubrey 'the most monstrous of orchids'. The evening was a triumph for Wilde's play, with only Shaw a dissenting voice. But outside the theatre, barred from buying a ticket, prowled the Marquess of Queensberry. Wilde's precarious double life was about to be exposed.

Wilde, who in January had been in North Africa with Lord Alfred Douglas, decided to challenge Queensberry's libel, the note left at his club addressed to 'Oscar Wilde posing as a Somdomite [sic]'. As Queensberry's evidence in support of his accusation became clearer, Wilde's friends tried to persuade him to drop the case. The libel trial duly collapsed, and a very brief interlude followed, during which Wilde's supporters advised him to leave for Paris. Wilde remained, and on the evening of 5 April he was arrested at the Cadogan Hotel. It was a highly public occasion, with the Press waiting *en masse*. Wilde was driven to Bow Street, with a yellow-backed book in his hand, and it was widely reported that he was carrying a copy of *The Yellow Book*. (It was actually a mildly erotic novel by Pierre Louÿs, *Aphrodite*.) Although Wilde had never contributed to *The Yellow Book* – he affected, at least, to despise it – the false connection was only too appropriate. In the minds of those hostile to the whole decadent, nineties movement, Beardsley, who after all had pictured Wilde's *Salome*, was guilty by association.

Design for *The Yellow Book*
A temptation scene, with a faun reading to the girl. The drawing was suppressed when Beardsley's work was removed from Volume V of *The Yellow Book* following Wilde's arrest.

Most people rapidly distanced themselves from Wilde. According to Henry Harland's facetious estimate, six hundred English gentlemen took the night boat to France, instead of the normal sixty or so. Robert Ross was persuaded by his mother to go to France. Reginald Turner was already there, Douglas would follow. Wilde's name was removed from the playbills of his two London successes. Ada and Ernest Leverson remained loyal. Wilde wrote to them from Holloway, 'With what a crash this fell! Why did the Sibyl say fair things?' (The Sibyl was the fashionable fortune-teller Mrs Robinson, who had got her predictions wrong.) 'I should love to see Oscar's letter,' commented Beardsley to Ada Leverson. 'Poor dear old thing. I am writing to him this morning. I suppose letters reach him all right.'

If he did write a letter, there is no record of it. A few weeks later he was striking a much less sympathetic note, with a punning glance at John Home's tragedy *Douglas*, and a chilling prescience about the fatal impact of Lord Alfred Douglas on Wilde's own future: 'I look forward eagerly to the first act of Oscar's new Tragedy. But surely the title *Douglas* has been used before.'

Wilde, quite unwittingly, had blocked Beardsley's career. It was as though Beardsley himself had been arrested, on a charge of creating immoral art. In New York John Lane read about the growing crisis. He cabled the Bodley Head office in Vigo Street, ordering all Wilde's books to be withdrawn from sale, not knowing that a crowd had already gathered outside his shop and stoned the premises where the window display had once created a mighty glow of yellow. (Miss Bradley and Miss Cooper – who wrote poetry as 'Michael Field' – when submitting a poem for publication, had blanched, blinded by the glare of Hell: 'The window seemed to be gibbering, our eyes to be filled with incurable jaundice.') Then Lane's other authors began to make their presence felt, notably the self-righteous novelist Mrs Humphry Ward, with whom Edmund Gosse unsuccessfully tried to reason. William Watson had an unmemorable poem due to appear in the next number of *The Yellow Book*. He marched in to the office, demanded to inspect Beardsley's cover design and disliked what he saw. Off went a cable: 'WITHDRAW ALL BEARDSLEY'S DESIGNS OR I WITHDRAW MY BOOKS.'

Lane's assistant, Frederick Chapman, took action. Beardsley lost his position as art editor, and his work was removed from Volume V, five plates and the front cover – Chapman overlooked the design for the spine and the back. As the novelist E. F. Benson recalled, the publication turned grey in a single night.

Harland was in Paris with his wife, and Beardsley joined them for a time. Harland does not seem to have realized that Beardsley's removal was to be permanent. He wrote to Edmund Gosse agreeing that Beardsley's absence from *The Yellow Book* was 'deplorable', adding:

> but what is one to do with a capricious boy whose
> ruling passion is a desire to astonish the public
> with the unexpected? He'll be in the July number,
> I hope, larger than ever.

Harland was, perhaps, being ingenuous. He made no move to have Beardsley reinstated.

Beardsley was shattered, but not cowed. The art critic of *St Paul's*, Haldane Macfall, attacked him, coupling his work with that of Wilde as unrepresentative, 'having no manhood ... effeminate, sexless and unclean'. Beardsley's reply, which was never published, was full of spirit: 'As to my uncleanliness, I do the best for it in my morning bath, and if he has really any doubts as to my sex, he may come and see me take it.'

Yeats has left an impression of Beardsley at this time in *The Trembling of the Veil*:

> He is a little drunk and his mind has been
> running upon his dismissal from *The Yellow Book*,
> for he puts his hand upon the wall and stares into
> a mirror. He mutters, 'Yes, yes, I look like a
> Sodomite', which he certainly did not. 'But no, I
> am not that!', and then began railing against his
> ancestors ...

There are all kinds of wild theories about Beardsley's sexuality, including the insinuations of the relentlessly untruthful Frank

Harris about Aubrey and Mabel. But it was what he was thought to be, rather than what he was, that mattered in terms of his career; and his art, to him, was everything.

Financially, he was in great difficulty. For a time no publisher would commission work from him; and he had to move out of 114 Cambridge Street. Meanwhile, a new patron had begun to befriend him: Marc-André Raffalovich. Mabel seems to have engineered the first meeting, by persuading Raffalovich to attend a lecture given by Beardsley. Raffalovich was a rich Russian of whom Wilde remarked that he had come to London to found a salon and only succeeded in founding a saloon. On one occasion, invited to a meal, Wilde rang the bell and announced, 'We want a table for six for lunch today.' Perhaps in revenge, Raffalovich broke up Wilde's friendship with the poet John Gray.

Beardsley now sought Raffalovich's advice, and began to address him as 'Mentor'. From Raffalovich, Beardsley received letters, gifts of flowers and chocolates, invitations to dine, and probably more advice and mentoring than he wanted. But his support helped Beardsley through the early summer of Wilde's three trials, and the gloating that accompanied the verdict, such as the *News of the World*'s delight that 'the aesthetic cult, in the nasty form, is over'.

Beardsley, in need of a holiday, gravitated to Dieppe. 'Really Dieppe is quite sweet,' he wrote to Rothenstein. 'It's the first time I have ever enjoyed a holiday.' Arthur Symons was there, and the publisher Leonard Smithers was to call in *en route* for Paris. Beardsley began to recover his spirits, and to make plans.

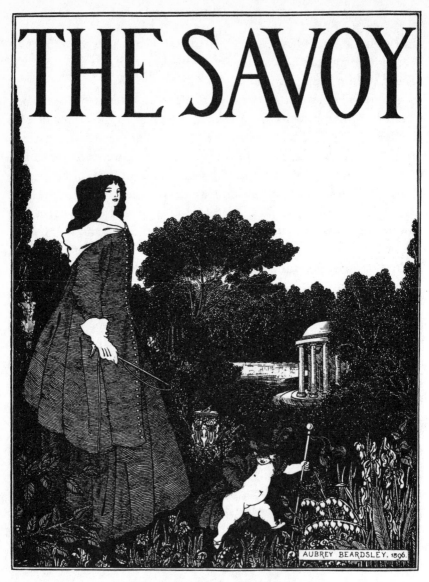

THE SAVOY

AUBREY BEARDSLEY. 1896.

Cover Design for *The Savoy*
The design used for the first number of the
magazine in January 1896. In the first version
the putto was shown urinating on a copy of
The Yellow Book, a provocation that, like the
putto's genitals, was removed.

MASQUERADE AT DIEPPE

T HE AESTHETIC CULT was in some collective disarray because of its association with Wilde. In so far as there was a discernible group or movement, which was not very far, it had moved its centre temporarily to Dieppe. There, at a table at the Café des Tribuneaux, *The Savoy* magazine was planned.

Beardsley's official involvement with *The Savoy* is not very clearly defined. Yeats was living in chambers in Fountain Court, the Temple, which opened into those of Arthur Symons, and recollected the day 'a publisher called and proposed that Symons should edit a review or magazine, and Symons consented on the condition that Beardsley were Art Editor'. The publisher was Leonard Smithers, solicitor, art dealer, bookseller, publisher and purveyor of fine editions and pornography. He had just brought out Symons's collection of poems, *London Nights*, which John Lane had turned down. This volume, dedicated by Symons to his friend Verlaine, was greeted with predictable howls of rage from the same sections of the Press that had condemned *The Yellow Book*. *The Pall Mall Gazette*, for example, called him a 'dirty-minded man', whose mind was 'reflected in the puddle of his bad verses' which recorded his 'squalid and inexpensive [if heterosexual] amours'. Verlaine and Yeats praised the book, and Smithers was ready to take up the mantle of publisher to the avant-garde, which Lane had let fall. Even the title was a signal of defiance, for the Savoy hotel was clearly identified with Wilde and his circle by its frequent mention in the trials. Although excluded as a contributor, as he had been from *The Yellow Book*, his artistic spirit was to be clearly invoked.

Smithers was described by Robert Ross as 'the most delightful and irresponsible publisher I ever met'. Wilde, who did not meet

him until his self-imposed exile in France in 1897, described him vividly for Reggie Turner:

> he is usually in a large straw hat, has a blue tie
> delicately fastened with a diamond brooch of the
> impurest water – or perhaps wine, as he never
> touches water: it goes to his head at once. His
> face, clean-shaven as befits a priest who serves at
> the altar whose God is Literature, is wasted and
> pale – not with poetry, but with poets, who, he
> says, have wrecked his life by insisting on
> publishing with him. He loves first editions,
> especially of women: little girls are his passion. He
> is the most learned erotomaniac in Europe ...

Wilde, much in need of new friends in 1897, added that Smithers was also 'a delightful companion, and a dear fellow'. His rackety life did not seem for once to bother Beardsley: here was a man prepared to publish anything that the 'others' – that is, every publisher in London – were afraid of.

Symons put a slightly different gloss on Beardsley's involvement with *The Savoy*. He had called on Beardsley in Cambridge Street to find him lying on a couch – 'horribly white; I wondered if I had come too late'; but he was singularly ready to fall in with the project when Symons asked him 'to devote himself to illustrating my quarterly'. Certainly, both the advertisement and the title-page of each number of the magazine state unequivocally 'Edited by Arthur Symons', with no official role ascribed to Beardsley. But if that was the public position – and given Beardsley's reputation, Smithers might have thought it sensible – Beardsley approached the project as though he was a close and essential collaborator. Besides, from this time on he became dependent on an irregular salary from Smithers (the sums varied, and the cheques were sometimes postdated).

Beardsley, who in the past had found it difficult to work outside London, now began to spend more and more time on the Continent. Dieppe appealed to him, with its rapid access to London via the three-hour ferry service and fast rail connection. It was a convenient stopping-off place on the journey to Paris, and many

artists and writers, English and French, made the town or the surrounding villages their summer, or even permanent, home. The town, the beaches and cliffs, and above all the light, had long attracted artists, among them Delacroix, Turner, Bonington, Renoir and Monet. The Francophile Walter Sickert and the Anglophile Jacques-Emile Blanche painted there each summer. Of Beardsley's friends or associates there might be a rolling selection, from Henry Harland, Charles Conder, Symons, Smithers, Rothenstein, Reggie Turner, Ernest Dowson, Max Beerbohm. Dieppe was somehow poised between France and England, a place where you could stay for a night or linger for months and years, a venue for an expensive family holiday, but also a context for the observer and the voyeur, or for a sexual encounter.

The public life of the Casino, where the Bal des Enfants and the gambling took place, or the bathing places where spectators sat on chairs to watch the activity, was only a short stroll from more ambiguous and marginally less respectable areas of the town; while on the other side of the harbour was a contrasting ambience in the

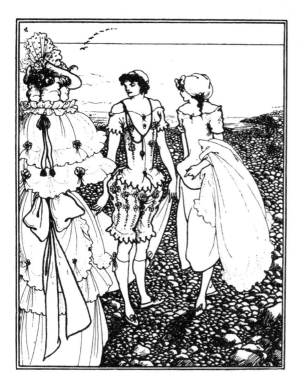

The Bathers
Beardsley's picture accompanies Arthur Symons's article 'Dieppe: 1895' in *The Savoy*, No. I. Symons enjoyed watching the actress Cléo de Mérode bathing with a gold chain over her costume.

narrow streets of the old fishing quarter, Le Pollet. Symons evoked the time and the place in his essay 'Dieppe: 1895', which was published in the first volume of *The Savoy*. Like Scott Fitzgerald in *Tender is the Night*, Symons conjured up an atmosphere of infinite possibility and allure, placing his emphasis, finally, on people, people with beautiful faces:

> people one never knew, and yet, meeting them at
> every hour, at dinner, on the terrace of the
> Casino, at the tables, in the sea, one seemed to
> know them almost better than one's friends, and
> to be known by them just as well.

Symons wrote to Herbert Horne (did Beardsley really once try to ravish Horne's lover Lucy in the supper room of the Thalia?) inviting him to come over and join the 'English colony', as though Dieppe was some kind of promised land:

> I promise you if you come that you will never
> return again – like, first, Conder, secondly myself,
> and thirdly Beardsley, who has determined to stay
> here, more or less, for ever … I am writing a good
> deal of verse, translating Verlaine, sitting for my
> portrait to Jacques Blanche, meeting Baronesses
> and chahuteuses from Bullier, bathing, lounging
> about the Casino, and altogether having the most
> amusing and irresponsible holiday I have had for
> a long time.

He ended the letter, 'Beardsley is waiting for me downstairs.'

A fortnight or so earlier, Charles Conder had written to Will Rothenstein urging him to come over and join the fun – in Conder's case, the fun tended to be active and sexually orientated, because in Dieppe, as far as he could see, 'one can do absolutely what one likes', and Smithers was often there. Rothenstein could draw his own conclusions. That morning, he had seen the dancer Cléo de Mérode bathing 'and wished I was King David, so pretty she was, and didn't get too wet. I stayed near her to stave off cramps and

drowning, but she could only say, the darling, that *J'ai peur ici des trous.*' 'Smithers has made Aubrey Beardsley editor of the new publication,' Conder added, inaccurately, 'I suppose you know that'; and, in another letter, 'there has been a great deal of excitement about the new quarterly here and discussion. Beardsley is very pompous about it all.'

While Symons and Conder could combine work and holiday, Beardsley's frailty meant that his pleasures, although intense, were more passive. According to Symons, he never walked (how could he?) and never looked at the sea, but at night he was almost always to be found in the Casino:

> watching the gamblers at *petits chevaux*, studying
> them with a sort of hypnotised attention ... He
> liked the large, deserted rooms, at hours when no
> one was there; the sense of frivolous things caught
> at a moment of suspended life, *en déshabille*. He
> would glance occasionally, but with more
> impatience, at the dances, especially the children's
> dances, in the concert-room; but he rarely missed
> a concert, and would glide in every afternoon, and
> sit on the high benches at the side, always
> carrying his large, gilt-leather portfolio with the
> magnificent old, red-lined folio paper, which he
> would often open, to write some lines in pencil.

Beardsley, like Symons, was painted that summer by Jacques Emile Blanche – the portrait was exhibited in London in the autumn at the Society of Portrait Painters Exhibition. Blanche remembered the improvised stories Beardsley told, which might serve for *The Savoy*, stories 'so daring that it would have been better had he told them in Greek'. He described a characteristic moment that summer, at the bathing hour:

Design for an invitation card
This was for John Lane's literary gathering, known as 'Sette of Odd Volumes Smoke'.

73

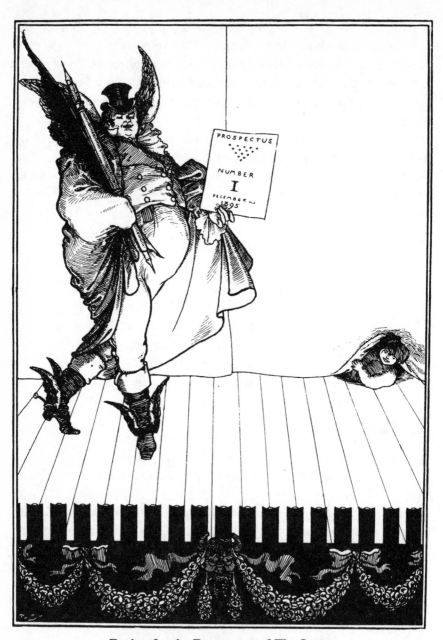

Design for the Prospectus of *The Savoy*
The bulge in Bull's trousers was described
as 'puerile mischievousness' by George Bernard
Shaw, and removed from the figure of
John Bull for the Contents page.

The Casino orchestra was playing a waltz by
Arban, the concert player of the Bal Musard in
the Champs Elysées. Aubrey Beardsley had
escaped from the Hôtel des Etrangers without the
permission of his mother, who was also his nurse.
He was coughing and muffled up, drinking a glass
of milk and soda under a coloured umbrella on
the terrace.

Beardsley had a wide knowledge of French literature – Balzac, naturally, George Sand, Gautier, with a special place for Alexandre Dumas's *La Dame aux Camélias*, the 'gentle courtesan consumed with phthisis'. Beardsley insisted that Blanche took him to Puys, just north of Dieppe, to meet the author, and Dumas *fils* gave him a copy, which Mabel would later place in her brother's coffin.

Beardsley's energies were channelled towards the new magazine, and he was seriously planning literary as well as artistic contributions. In late September he was urging Smithers to 'get the block of the cover made as soon as possible' – and, in the same letter, begging 'For Satan's sake send me *de quoi vivre* and quickly. This I ask as charity and not by right.' He acknowledged the cheque in his next letter, though it would not be enough to buy a ticket back to London. He reported that a *Savoy* drawing was in hand and that the *Tannhäuser* was going on well. This was his long-digested, infinitely malleable set of variations, in prose of an 'icy artificiality', on the story of Venus and Tannhäuser. The first three chapters would appear, illustrated and expurgated, in the first number of *The Savoy*. Meanwhile, Beardsley watched the innocent amusements and entertainments in the Casino, and composed an elegant, erotic counter-text in his gilt-leather portfolio.

Beardsley the art editor was becoming difficult to control. His first suggestion for *The Savoy* prospectus used the figure of Pierrot, part of Beardsley's private mythology since his childhood in Brighton, and perhaps brought back to his mind by the theatrical atmosphere of Dieppe. Smithers thought 'John Bull' might prefer something more 'serious', so Beardsley substituted a substantial, winged John Bull, clutching a bundle of pens and stepping on to a stage to announce the first number: he was also sporting a small

erection. George Moore, one of the prospective contributors, was not amused, and headed a deputation to Smithers. The 'subtle stroke that emphasized the virility of John', in Shaw's phrase, had to go; Smithers, who had already distributed 80,000 copies, consented.

Beardsley's sense of mischief was fully tuned that summer. His first drawing for the cover featured, in addition to a tall, severely dressed woman with a riding whip in her white glove, a largely undressed putto with feathered hat, cane and slippers, his genitals precisely positioned above a copy of *The Yellow Book* (in the original drawing Beardsley included a stream of urine). This squib was clearly designed as Beardsley's revenge on Lane, much as Wilde used Lane's name as Algernon's manservant in *The Importance of Being Earnest*: after all, Beardsley had been summarily removed from his last post because of *The Yellow Book*'s chance associations.

There are all sorts of tensions and meanings suggested in the drawing, with its elements of an eighteenth-century pastoral landscape, the echo in the woman's appearance of Beardsley's *Yellow Book* women, the mixture of gloved, buttoned restraint and the licence hinted at by the pagan temple and the three satyrs on the sundial. It was all too much for Smithers and the contributors, who were no doubt looking forward to a long, unscandalous and prosperous association with *The Savoy*. The putto changed sex and acquired clothes, and *The Yellow Book* vanished. Announced originally for December and the Christmas market, the magazine's launch was postponed until 11 January 1896.

The Savoy seems now a far more substantial and avant-garde magazine than *The Yellow Book*. The contributions of Yeats, Symons and Beardsley dominate, but the first issue also contains work by Shaw, Havelock Ellis and Dowson. Beardsley's three chapters of *Venus and Tannhäuser*, their accompanying illustrations, and his illustrated poem 'The Three Musicians', ensured that his style attracted the reviewers' eyes. There was the usual reaction from *Punch* – 'Mr Weirdsley's illustrations' – but *The Sunday Times* singled out the 'splendid decorative effect' of Beardsley's designs, and the general response was relatively positive.

Smithers celebrated with a private supper party at the New Lyric Club, and afterwards at his flat: Smithers and his wife, Symons, Yeats, Beerbohm, Beardsley and Mabel. Symons had persuaded a

reluctant Yeats, who thought Smithers a 'scandalous person', to attend. Yeats had just received two letters, one from T. W. Rolleston and one from 'A. E.', denouncing him for writing for such a magazine, the 'Organ of the Incubi and the Succubi'. According to A. E., Symons read out the letter, and presently Beardsley came over and said:

> Yeats, I am going to surprise you very much. I
> think your friend is right. All my life I have been
> fascinated by the spiritual life – when a child I
> saw a vision of a Bleeding Christ over the
> mantelpiece – but after all, to do one's work when
> there are other things one wants to do so much
> more is a kind of religion.

Later, Yeats arrived at Smithers's place to find Beardsley 'propped up on a chair in the middle of the room, grey and exhausted'. He went into another room to spit blood, then returned and urged Smithers to continue turning the handle of a hurdy-gurdy piano. Plainly, Smithers had had enough of this diversion, 'but Beardsley pressed him to labour on, "The tone is so beautiful", "It gives me such deep pleasure", etc., etc. It was his method of keeping our publisher at a distance.'

Whatever Beardsley felt about some aspects of Smithers, he responded enthusiastically to his next proposal, which was to illustrate Pope's *The Rape of the Lock*. In February he left London for Paris, where he worked steadily, in spite of the distraction of toothache and diarrhoea. He read the 'evergreen and comforting' novels of Balzac, which Smithers sent him, and corresponded with potential contributors to *The Savoy*. He spent several evenings with Dowson, and Smithson would join them on his frequent forays to Paris. On one occasion, Dowson recalled, in company with Smithers and Yvonne – a girl from the Thalia club – Beardsley took hashish at the house of the journalist Gabriel de Lautrec. It worked very promptly:

> Luckily we were in a *cabinet* or I think we would
> have been turned out – for Beardsley's laughter
> was so tumultuous that it infected the rest of us –

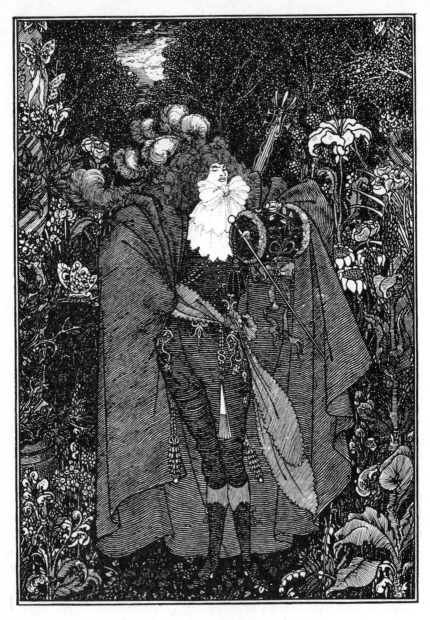

The Abbé
The illustration accompanied the excerpt from
Beardsley's unfinished novel *Under the Hill* that appeared in
The Savoy, No. I. Beardsley's initials, A. B., would be
pronounced '*Abbé*' in French.

who had *not* taken hashisch & we all behaved like
imbeciles.

On 11 February Beardsley and Dowson went to see Wilde's *Salomé*
at the Théâtre de l'Oeuvre. It was a triumph.

In March Aubrey could report to Mabel that *The Rape of the
Lock* was finished. He also sent her a prayer-book, to mark her
reception into the Roman Catholic Church. 'I don't know when I
shall return to London,' he told her, 'filthy hole where I get nothing
but snubs and the cold shoulder.' Later in March he was in Brussels.
According to Dowson, Beardsley went to see Smithers off at the
Gare du Nord, and, just as they all used to slip over to Dieppe on
the spur of the moment, decided to accompany him. (Whatever the
circumstances, he left Paris without paying his bill at the Hôtel St
Romain.) But once in Brussels he fell ill, and had to be nursed by
Smithers and Mabel.

Temporarily recovered, he posted off a cover design for the
second, April number of *The Savoy* – 'The little creature handing
hats is not an infant but an unstrangled abortion' – and Chapter
Nine of *Under the Hill*, which turned out to be 'The Ballad of a
Barber', a chilling piece indebted to a poem by John Gray. Beardsley
was then horrified to hear from Smithers that Symons thought it
'poor'. First he suggested printing it under a pseudonym, and
separately from *Under the Hill* – what about 'Symons' as a *nom de
plume*? Two days later he returned to the subject at greater length.
The writing of the poem and the illustration had taken five days:

> I could have been doing other things if I had
> known that Symons would have made
> arrangements to keep things of mine out of the
> magazine. Surely as literary editor he could have
> written to me earlier saying that the last verses
> must be rewritten; you know how willing I am
> always to make alterations and listen to
> suggestions.

Beardsley felt bitter towards Symons, who was named as the editor
in the second number. He was acutely conscious of the problems

that being away from London caused. He was also very unwell, attended regularly by the doctor, and anxious about the mounting bills. Brussels was becoming impossible. Smithers kept sending him money and, with the Pope completed, commissioned Beardsley to make a set of eight illustrations for Aristophanes's *Lysistrata*. Beardsley vowed to start work on these, though, he reassured Smithers, he would not post any of the results, presumably for fear that they might be pounced on as obscene by a customs official. His recovery was painfully slow, and he reported each minor triumph as he managed to leave the hotel and have a short walk, in defiance of his doctor's orders; his breathing was still bad, and stairs were an impossibility. By the beginning of May he was amusing himself with limericks:

> There once was a young invalid
> Whose lung would do nothing but bleed.

'Symons shall finish it if he is a good boy,' he wrote to Smithers. He sent for Mabel, to accompany him back to London; she was unable to come, and his mother, unwell herself, crossed to Brussels to bring him back. Ross found him rooms in Campden Grove, Kensington, where he was within reach of his regular doctor.

One evening he came face to face with Whistler, whose coldness and apparent scorn had hurt him for so long. He had gone to visit Pennell, to show him the drawings of *The Rape of the Lock*. Beardsley showed them, one by one, to Pennell, who in turn passed them to Whistler.

> Whistler looked at them first indifferently, then
> with interest, then with delight. And then he said
> slowly, 'Aubrey, I have made a very great mistake –
> you are a very great artist.' And the boy burst out
> crying. All Whistler could say, when he could say
> anything, was 'I mean it – I mean it – I mean it.'

The Rape of the Lock was published, and he sent a copy to Edmund Gosse, to whom it was dedicated, and another to the French singer Yvette Guilbert, who was appearing at the Empire Theatre. On his

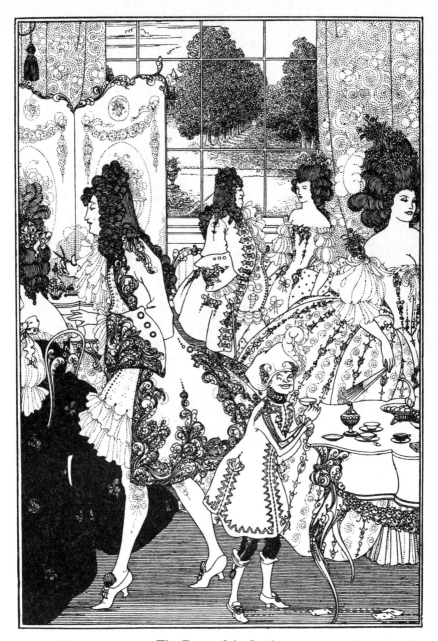

The Rape of the Lock
The edition illustrated by Beardsley was published by Smithers
in 1896. This scene depicts the Baron in the act of approaching
Belinda, seated with her back to the spectator. The page boy,
too, helps himself. In the background, the formal landscape
suggests Hampton Court, setting for the rape.

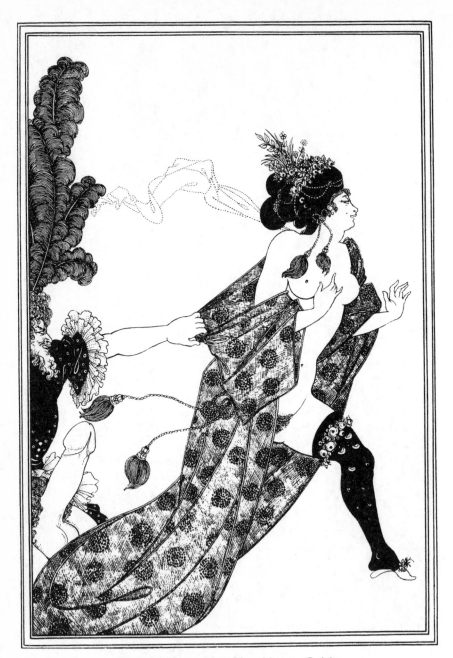

Cinesias Entreating Myrrhina to Coition
Beardsley drew eight illustrations for *Lysistrata*. For once,
Beardsley can hardly be accused of creating anything not in
the spirit of the original, his sense of humour coinciding with
Aristophanes's comic treatment of male absurdity.

doctor's orders he went to Crowborough for a complete rest – no drawing – and then to Epsom.

The third number of *The Savoy* came out in July. It included Beardsley's revised poem 'The Ballad of a Barber', accompanied by his own illustration of the artist-barber about to kill – or seduce – the thing he loves, the young Princess:

> The Princess gave a little scream,
> Carrousel's cut was sharp and deep;
> He left her softly as a dream
> That leaves a sleeper to his sleep.

There were poems and translations by Symons, Dowson, George Moore and Yeats, and an article by Yeats on Blake and his illustrations to Dante's *Divine Comedy*. W. H. Smith chose this moment to refuse to stock the magazine on their railway bookstalls. Symons confronted the manager who, 'no doubt looking for a design of Beardsley's, pitched upon' a Blake nude of Antaeus as the grounds for refusal. To Symons's defence that Blake was considered 'a very spiritual artist', the reply was 'O, Mr Symons, you must remember that we have an audience of young ladies as well as an audience of agnostics.' Yeats wrote to a 'principal daily newspaper', making the mistake of referring to Beardsley; he was informed that the editor refused to print any mention of Beardsley's name. This setback coincided with Smithers's bold decision to convert *The Savoy* from a quarterly to a monthly. It also coincided with a critical period in Beardsley's health, so that, although he was well represented in the succeeding numbers, many of his contributions were in fact drawings that he had already completed rather than new work.

In June, instead of returning to Crowborough, Beardsley was installed at the Spread Eagle Hotel, Epsom, in two 'palatial' rooms. He wrote to Smithers with renewed buoyancy to assure him that there was progress on the *Lysistrata* commission: 'I have taken a half-holiday today as the haranguing picture is completed beautifully, and the pencil work for the obstreperous Athenians as well.' A few days later he was enclosing a proof: 'The rampant Athenians are finished finely; and if there are no cunts in the picture, Aristophanes

Et in Arcadia Ego
Published in the last number of *The Savoy*,
No. VIII, in December 1896. The ageing dandy
contemplates a *memento mori*, while the design
emphasizes the isolation of the 'ego'.

is to blame and not your humble servant.' In this interlude Beardsley exuded energy and ideas, and the optimism which accompanied any remission in his disease. The *Lysistrata* would be finished in a week, drawings for numbers five and six of *The Savoy* would take about a fortnight. What would the Christmas book be? *Ali Baba and the Forty Thieves*, he hoped – it would make a scrumptious book and his head was full of it.

As a counter-narrative to this enthusiasm runs a parallel set of notes and postscripts, which begin quietly, 'Cough about the same. Very many thanks for the £3'; move on to, 'Doctor just been down. He says my left lung is breaking down altogether and that the right is becoming affected'; and then climax in full detail, 'The doctor has given me a wonderful medicine which makes my shit black and head ache. Ammonia, potassium, belladonna and chloroform are among its simplest ingredients.' By the middle of July the severity of his symptoms had receded a little, and he could rejoice that *Lysistrata* was finished and refer to his 'little setback'. But his mood swung violently, according to his strength. He saw few people, apart from his family, and never even went to visit Raffalovich, who had taken a house for the summer a few miles away at Weybridge: this may have been to avoid cross-questioning about the *Lysistrata* project, about which Beardsley wrote to him in extremely circumspect terms – 'I think they are in a way the best things I have ever done' – before shifting the subject to his next project, the less problematic pictures and translation of Juvenal's sixth satire.

Mabel had found a new refuge for her brother – Pier View, Boscombe, an area of Bournemouth. Dieppe was less convenient for the family, and Beardsley confessed that he rather 'funked' going, in case he was arrested over the Paris hotel debt. 'I don't believe there's a gendarme in France who hasn't either my photograph or a model of my prick somewhere about him.' Throughout August and September Beardsley was occupied with Smithers's project for *A Book of Fifty Drawings*, collecting together the best of his work. Mabel was commissioned to call on Lane and Dent to obtain their permission. Aymer Vallance offered to compile a complete iconography. The photographer H. H. Cameron did some studies of Beardsley, one of which was used as a frontispiece. Letters were despatched in all directions to seek agreement from publishers, and

to track down copies of plates and posters; and Beardsley gave detailed instructions about the paper and binding cloth. He did manage to get up to London, but the exertion brought on a serious attack of haemorrhage, and most of the negotiations were carried out frustratingly by penny post. 'When do you think the album will be ready?' he asked Smithers in September. 'I am worrying myself into an early grave.'

The Savoy's imminent demise was announced in the seventh number, with Beardsley represented by a translation of Catullus, and a drawing, 'Ave Atque Vale', which might serve as his own farewell. *The Savoy* did not survive beyond December 1896; and the last number was written entirely by Symons, perhaps because there was no money to pay any other contributor. The writer Hubert Crackanthorpe, an avid disciple of Guy de Maupassant and himself a *Savoy* contributor, suggested to the publisher Grant Richards that he might continue the magazine, with himself as editor, but then disappeared abruptly from London. His body was later found in the Seine. 'Poor Crackanthorpe! His life was as short as one of his stories,' commented Rothenstein, adding that his suicide was said to be 'the judgment of God for adoring French idols'.

Beardsley was strongly featured in the last issue: it offered a kind of retrospective of some of his favourite themes and subjects and included Mrs Margery Pinchwife from Wycherley's *The Country Wife*, 'A Répétition of Tristan und Isolde', four illustrations of *Das Rheingold* and 'Et in Arcadia Ego', which, among other references, seems to comment on Beardsley's consciousness of impending death. 'Words cannot describe the simple agony of depression into which I seem to have fallen chronically,' he commented to Smithers when he sent the drawing to him. 'Here is the last of No. 8.'

Meanwhile Raffalovich was beginning to press Beardsley towards conversion to the Catholic faith. Beardsley's relationship with Raffalovich is a little difficult to assess and define, especially since his largely conventional, serious, even pious letters to 'My dear André' alternate with a parallel correspondence with Smithers, which is direct, uninhibited and sometimes full of savage or obscene humour. To Raffalovich Beardsley expressed gratitude, for chocolates, news of the theatre and books – books Beardsley had asked for, at Raffalovich's kind invitation, and books that were

intended to speak to him of the spiritual life. Raffalovich sent him parcel after parcel of them – an album of Claude Lorraine's, from which Beardsley planned to 'pilfer' ships and seashores, or a 'nice little packet of French books'. He also arranged for a Jesuit father to call on Beardsley – 'most charming and sympathetic' – and suggested decorous works, such as Stendhal's *Armance*, for illustration, and Benjamin Constant's *Adolphe*, translated by John Gray. At the same time Beardsley was asking Smithers for a complete *Liaisons Dangereuses*.

Winter approached. Beardsley viewed it with anxiety. Mabel was leaving him, sailing to New York for a three-month theatre tour of North America. He suffered a painful tooth extraction, which he duly illustrated for Smithers – 'You see even my teeth are a little phallic'. He began to look forward to staying in London with Raffalovich for the New Year. But early in December, when he was out walking with his mother, he collapsed with a sudden and severe attack of bleeding. 'You might have tracked our path down, the bleeding was so profuse,' his mother told Ross. 'I expected to make an "al fresco" croak of it,' Beardsley informed Smithers. 'I struggled peniblement to where I expected a drinking fountain. There *was* one there, and so the pretty creature drank.'

He spent Christmas very quietly. There were presents or letters from Raffalovich, Gray, Ross, Max Beerbohm. To Raffalovich he wrote that he was unable to get to any service, but added that his mother had given him a life of Bossuet and a little book on the Blessed Sacrament. For Smithers, a week later, he compiled an obscene and sacrilegious limerick, and commented, 'Ye gods what a feast is Christmas!' But he also announced that on New Year's Day, 1897, there was to be a 'grand specialists' consultation' to decide whether he was well enough to travel to London.

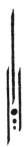

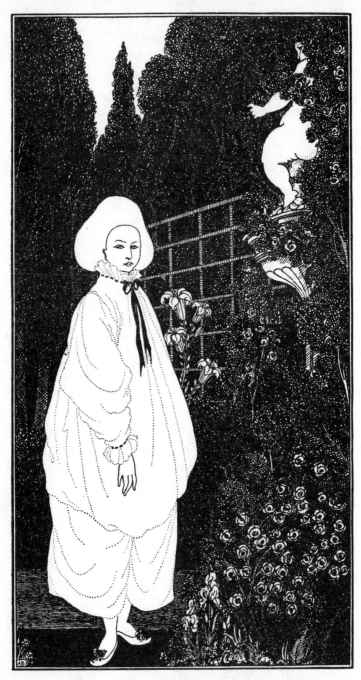

Frontispiece to *The Pierrot of the Minute*
Ernest Dowson's 'Dramatic Phantasy in One Act' was
published by Smithers in March 1897. Beardsley invokes
the idealized pastoral world of Watteau in this design.

FAREWELL TO ART

T HE YEAR BEGAN wretchedly for Beardsley. He had, as he described it to Raffalovich, 'collapsed in all directions': he was depressed, shaky, feverish, 'in a highly negative state' – in other words, in no position even to think about drawing, let alone executing anything. London, where his imagination and energy might be fired, seemed impossibly distant, and a rare edge of complaint and resentment entered his letters: 'I feel utterly helpless and deserted down here, and at the mercy of my surrounders.' He was longing for a move, which usually brought him some relief from his depression, but his illness entered an acute phase. At the end of a bitterly cold January he was carried downstairs and taken in a heated carriage to new lodgings, in Bournemouth itself, a little way back from the sea. The house was called 'Muriel'. He suffered a little from the name, he confessed to Gray, feeling 'as shy of my address as a boy at school is of his Christian name when it is Ebenezer or Aubrey'.

The days passed slowly. Smithers paid a visit, and Beardsley was temporarily cheered to remember that he had made pictures for Dowson's play *The Pierrot of the Minute*, which Smithers was publishing. Mabel was still in America and had joined Mansfield's company, which was good for her career, but it meant that he would not see her until June, by

Design for the front cover of
The Pierrot of the Minute
The figure was in gold on a green cloth binding for the 'ordinary' edition.

which time his lungs might have done 'dreadful things'. Raffalovich continued to urge him towards Roman Catholicism, a step that Beardsley saw as conflicting with his life as an artist. 'If Heine is the great warning,' he wrote:

> Pascal is the great example to all artists and
> thinkers. He understood that, to become a
> Christian, the man of letters must sacrifice his
> gifts, just as Magdalen must sacrifice her beauty.
> Do not think, my dear André, that your kind
> words fall on such barren ground. However I
> fear I am not a very fruitful soil; I only melt to
> harden again.

Practically the same day, he began a watercolour drawing for Gautier's *Mademoiselle de Maupin* and started to make enquiries about rooms in Bloomsbury with a studio.

Beardsley was, he claimed, desperately short of money. Smithers's monthly sums did not stretch very far. Creditors began to press for payment. Harry Pollitt came down to visit him, and Beardsley sold him 'The Impatient Adulterer', illustrating Juvenal VI 237–8, which he had left unfinished. This eased the situation a little, but there were problems with Doré, his tailor, who had issued a writ over an old account. Bailiffs were threatened, and Beardsley feared for his shirts and socks. He had to persuade Pollitt to pay him in advance for the completed version of 'Bathyllus in the Swan Dance', as he was not strong enough for an impromptu flitting.

In February Raffalovich travelled down from London to see Beardsley, and a few days later Father David Bearne called, the first of many visits. Bearne was himself a convert, and Beardsley liked him immensely. Raffalovich was in the process of offering not just generous presents but a regular quarterly income. This enabled Mrs Beardsley to devote herself wholly to nursing her son, and allowed the projected move to London, or – as the destination was soon changed – to the South of France, to become a reality. 'I shall receive very gratefully and very affectionately the wonderfully kind help that you give me,' wrote Beardsley at the end of February, 'offered with so much intention and so much gentleness.' Father Bearne's visits

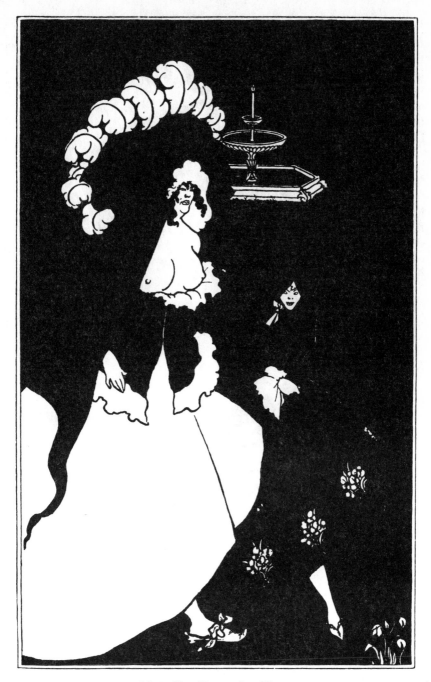

Messalina Returning Home
An illustration of *c.* 1896 to Juvenal, whose satires
Beardsley admired for their 'scorn and indignation'.

91

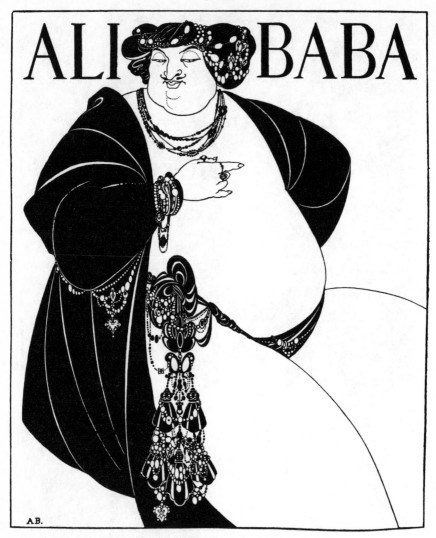

Design for a cover for *The Forty Thieves*
There is more than a hint of a caricatured Wilde
in Ali Baba's features in the design for a projected
edition of the book. Beardsley was working on this
in 1896, at the same time as *Lysistrata*.

continued, and Beardsley could joke to Smithers, 'I hope you are not haunted too cruelly with visions of designing Jesuits.' But he was entirely serious about the instruction he was having, and on 31 March 1897 he made his first confession and was received into the Catholic Church. From now on he could address Raffalovich as 'Brother'. On Friday 2 April Beardsley wrote to tell him that the Blessed Sacrament had been brought to him that morning: 'It was a moment of profound joy, of gratitude and emotion.'

Raffalovich now eased his friend's passage through London to Paris. He provided a little flat at the Hotel Windsor, in Victoria Street, for Beardsley and his mother. Priests and doctors attended. Father Bampton came round, and would have arranged for Cardinal Vaughan, the Archbishop of Westminster, to confirm the new convert, had there been more time. Raffalovich generously persuaded his own doctor to travel over to Paris with them, which was just as well as Beardsley was ill in the train on the way to Dover. But Paris revived him. It was, he wrote to Mabel, 'the blessed place it always was', and soon he was walking about in the streets – 'as pertinaceously as a tart', as he put it for Smithers. His room in the Hôtel Voltaire overlooked the *quai*, and the Louvre. He visited cafés and restaurants – it was such a treat to eat in a public place again – and his appetite returned. 'I lunched at Laperouse today as one of the Forbes Robertson family was with us. *Truite de Rivière*! Ah! and *Pontet Canet*! *Fraises*!' He visited the bookshops and print shops – sorely tempting (he bought two delicious *dix-huitième* engravings from the Goncourt Sale, 'dreadfully depraved things'); and he enjoyed sitting again in a café that filled up with animated spectators during the entr'actes of the matinée at the Théâtre Français.

His thoughts stirred, as always, towards drawing. He did a coloured frontispiece for a new miniature edition of *The Rape of the Lock*, and wondered about contributing a picture of Bathyllus for a history of dancing, at William Heinemann's invitation; and he designed a cover of Ali Baba. But these projects, so enthusiastically referred to in his letters, were largely illusory, fitted into rare intervals between the inevitable relapses. Yet it was all immeasurably better than Bournemouth, in terms of surroundings and distractions, and he saw his friends quite as often. Smithers was always crossing over to Paris, on business or in pursuit of his

doubtful pleasures. Will Rothenstein called, and did a portrait. Raffalovich and Gray arrived, *en route* for a holiday in Touraine.

Now Beardsley heard of a little place just outside Paris where he could spend the summer, at Saint Germain-en-Laye – simply Elysian. The rooms were charming, and cheap. The Pavillon Louis XIV was scarcely fifty yards from the terrace and park, and there was even an *ascenseur* at the station. (When Beardsley first arrived at the Hôtel Voltaire, which had no lift, the *garçons* had to carry him up and down stairs.) By the end of May Beardsley was installed at Saint Germain, to be joined a few days later by his mother.

For a brief while Saint Germain provided a welcome change. There were no distances to cover, the food was fine, the weather good enough for him to sit out of doors; there was a nice, convenient church, and 'such pretty theatres for Guignol and all sorts of *fantoccini* under the trees'. This account was for Raffalovich and Gray; to Smithers and Rothenstein he could confess that the move had fatigued him horribly. For reading he had bought a complete works of Casanova. 'Would that I had strength to make some pictures for him,' he wrote to H. C. Pollitt.

He fell into the hands of a new doctor, said to be one of the 'most learned and skilful doctors in France', who expressed confidence in his patient's ultimate recovery, condemned Bournemouth as the worst possible place, second only to the South of France, and prescribed an alarming régime that condemned Beardsley to rising at four in the morning and taking two hours' airing in the Bois. A few hours after the consultation he had a violent attack of haemorrhage, so the treatment was postponed; but then Beardsley found that those two dawn hours were his best for sleep, so the prescription was altered to staying in bed with the window open. More cheering was a brief visit from Mabel. But mother and sister were clearly anxious, and Raffalovich suggested a long-distance consultation with Dr Philips in Mayfair; he also arranged for his friend to travel to Paris, to see Dr Prendergast. The result was another move, to try some sea air, and Dieppe was the choice. Beardsley and his mother had a difficult journey – they were nearly turned off the ten o'clock train from St Lazare because they were not booked through to London. But they stood their ground, and Beardsley was soon enjoying the less oppressive temperature and

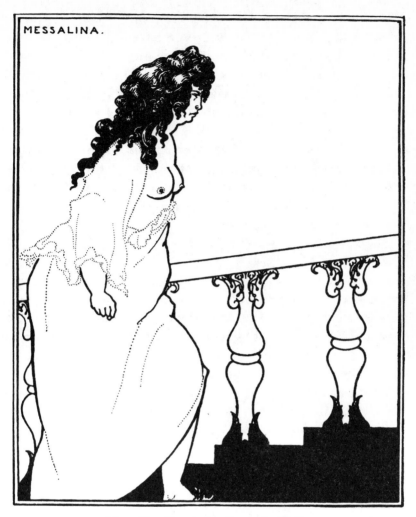

MESSALINA.

Messalina Returning from the Bath
Juvenal's *Sixth Satire* was privately printed by
Smithers in 1897. Messalina returns after a night
spent in active search of sexual pleasure, clearly
dissatisfied: one of Beardsley's most terrifying
images and a satiric match for Juvenal's
scourging of the times.

gentle winds of Dieppe. He had a really fine room, and found himself leading 'almost precisely the same life' as he had two years before, 'doing the same things at the same time'.

That 'almost precisely' sounded the alarm. Beardsley was dying, and he was now a Catholic; besides, he depended on his mother's care, and he was under the financial protection of Raffalovich. The Dieppe circle of artists and writers surrounded him, and welcomed him. Within a few days he had been invited to the Saint-Saëns festival. He dined at the home of the hospitable Norwegian painter Fritz Thaulow, and even managed the ten-minute walk back to the Hôtel Sandwich at eleven o'clock at night. Old friends were in the town, or passing through: Blanche, Conder, the poet Vincent O'Sullivan. So, too, was Oscar Wilde.

Wilde, after his release from prison, had stayed for a while in Dieppe, before moving a few miles north to the greater seclusion of Berneval-sur-Mer, where he was less exposed to the insults and slights that were still aimed at him. He was going under the name of Sebastian Melmoth, a soubriquet that deceived nobody but placated the hoteliers, and writing the one great work of his post-prison period, 'The Ballad of Reading Gaol'.

Wilde came into Dieppe frequently, using the Café Suisse or the Café des Tribuneaux or the Hôtel Sandwich as temporary bases, and on Saturday 24 July he met Beardsley, who, he told Ross, 'was looking very well, and in good spirits ... I hope he is coming out here to-morrow to dine'. Smithers was also staying that weekend at the Sandwich, as Beardsley had arranged. This was the first time Wilde had met Smithers, whom he described as 'very intoxicated but amusing'.

This reunion between Beardsley and Wilde would seem to have prompted Beardsley's next letter to Raffalovich:

> It is just possible I may be leaving this hotel at
> once. Some rather unpleasant people come here.
> For other reasons too I fear some undesirable
> complications may arise if I stay.

In the same letter Beardsley thanked Raffalovich for a cheque for £90, and he may have been worried that his mentor would withdraw

financial support if he learned that he was meeting Wilde regularly. Mrs Beardsley, too, was hostile towards Wilde, and encounters at the hotel would be embarrassing. There was, finally, a possible complication arising from a meeting between Wilde and Smithers.

Wilde as author, shunned by other publishers, was just the kind of challenge Smithers liked. He wooed Wilde with a parcel of books, and Wilde responded by completing his poem. Smithers was in Dieppe almost weekly – Wilde, in the letter to Reggie Turner that described him as 'the most learned erotomaniac in Europe', added, ominously, that he was 'the publisher and owner of Aubrey'. Wilde must have seen Beardsley several times, for he wrote to Turner, 'I have made Aubrey buy a hat more silver than silver: he is quite wonderful in it.' But this was a false brightness, a straining for a mood and a relationship that were no longer possible, and certainly not sustainable.

The conjunction of Lane and Wilde had been immensely harmful for Beardsley. Now Smithers was clearly lining up Wilde as one of his authors. When 'The Ballad of Reading Gaol' was finished, Smithers showed it to Beardsley, and reported back that Beardsley was 'much struck with it. He promised at once to do a frontispiece

Design for the front cover of
The Houses of Sin
Vincent O'Sullivan's book was published by Smithers in 1897, the design printed in gold on vellum.

for it – in a manner which immediately convinced me that he will never do it.' Smithers added, with apparent insensitivity about Beardsley's frailty, 'He has got tired already of Mlle de Maupin and talks of Casanova instead. It seems hopeless to try and get any connected work out of him of any kind.' Wilde wanted a definite answer: 'If he will do it, it will be a great thing.' But Beardsley hedged. If he had the impulse, he did not have the energy; and the certain disapproval of his mother, and of Raffalovich, quite apart from his own ambivalence towards Wilde, and the artistic harm the association had done him in the past, disturbed him.

Once, Beardsley, in company with Conder and Blanche, apparently ducked into a sidestreet to avoid a meeting with Wilde. 'It was *lâche* of Aubrey,' complained Wilde bitterly to Vincent O'Sullivan.

> If it had been one of my own class I might
> perhaps have understood it. I don't know whether
> I respect most the people who see me or those
> who don't. But a boy like that, whom I made! No,
> it was too *lâche* of Aubrey.

The artists were in their different ways too deeply wounded, and at the same time too proud, to collaborate. It was better for each to admire the other's qualities at a distance. Smithers did not persist in the project – though Beardsley's emphatic 'yes I'm at work!' may have deluded him momentarily – eventually publishing 'The Ballad' in February the following year.

Beardsley did complete the cover design for O'Sullivan's book of decadent poems, *The Houses of Sin*. His variation on the breeze as a winged head was to transform it into a pig-woman, whose snout is kissing the baroque pillar of, presumably, the House of Sin itself. 'It is to be printed in gold upon black smooth cloth,' Beardsley instructed Smithers. 'No other way. Purple however might be an alternative to print upon.' The final choice was gold on cream.

The summer turned cold and blustery. Beardsley was ill at ease, and his thoughts were already looking ahead to winter, and to Paris. Ellen Beardsley had to visit her own sick mother in Brighton; Mrs Smithers was staying at the Sandwich, and would look after him if

The Lady with the Monkey
Originally intended for *Volpone*, the drawing was included in a collection of *Six drawings Illustrating Theophile Gautier's Romance Mademoiselle de Maupin by Aubrey Beardsley*, published by Smithers in 1898.

The Lady with the Rose
Mademoiselle de Maupin, a novel about the search for a sexual ideal, surreal and theatrical, explored territory both familiar and congenial to Beardsley.

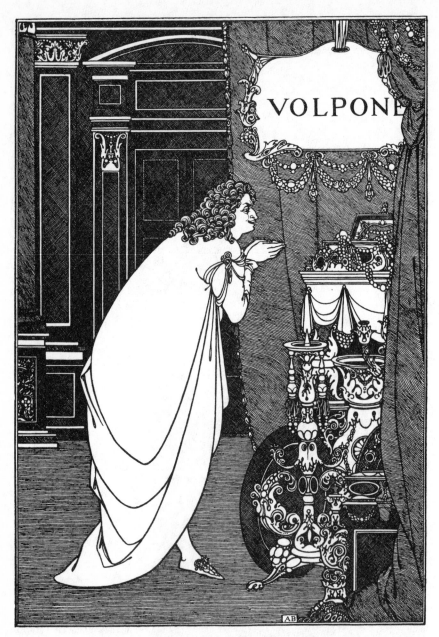

Volpone Adoring His Treasure

The frontispiece to *Ben Jonson his Volpone: or The Foxe*,
published by Smithers in 1898. Beardsley called it 'one
of the strongest things I have ever done'. Unusually for
him, it illustrates a scene directly and literally – Volpone
worshipping his gold at the beginning of the play.

he fell ill. He longed for Mabel to come and keep him company, but she had a series of theatre engagements in London. The unpleasant people came and went. Conder got drunker and drunker, and his bill at the bar mounted. Dowson, hearing that Beardsley was dying, travelled over from Brittany to see him and Wilde, scattering a trail of debts in his wake.

At the end of August Beardsley was moved into another hotel, more sheltered, where the food was better and where the unpleasant people did not bother him. Dr Philips arrived, to give him a thorough examination:

> He thinks I have made quite a marvellous
> improvement since he saw me at the Windsor
> Hotel, and that if I continue to take care I shall
> get quite well and have a new life before me.

Philips recommended Paris as the best place for the autumn. On 14 September Beardsley moved to Paris, to the Hôtel Foyot, facing south and looking over the Luxembourg Gardens, and immediately he missed Dieppe, 'the most charming spot on earth'.

These two months marked a diminution in Beardsley's imaginative energy, though from time to time he rallied, in response to an optimistic forecast from his doctor. He designed a bookplate for Olive Custance, and went on with the illustrations to *Mademoiselle de Maupin*, a project to which he was deeply committed. To his great disappointment, Smithers began to prevaricate. Smithers's finances were always speculative, and the expense of bringing out the edition of *Mademoiselle de Maupin* was formidable. Beardsley was locked into an exclusive contract with Smithers, and began to wonder how he could get out of it. 'I am utterly cast down and wretched,' he wrote to him. 'I have asked my sister to come and see you and have a talk with you.' He suggested that Smithers should sell the drawings he had already done, and that any further payments should be for fresh drawings 'for some smaller work that could appear complete in the immediate future.' He was anxious about money, but, far more than any financial need, he wanted his drawings to be published. 'Really nothing but work amuses me at all,' he confessed to Mabel. 'I am at work again and I

Initial V for *Volpone*
Beardsley used pen and ink, and pencil, for the initials, and sent strict instructions to the block-maker not to touch the surface, for fear of smudging. The illustrations were produced by the photogravure process.

Initial M for *Volpone*
Once again Beardsley seems to be intentionally fusing the Christian with the pagan since the woman and child could be read as Venus and Cupid or as the Madonna and Child.

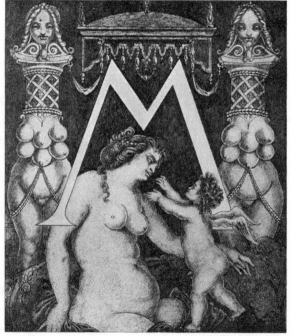

hope on some very good drawings.' Beardsley could not help feeling Smithers had honourable intentions – it would not be in his interests to ill-treat him. The next day he was hunting round the print shops for a fine picture of a fox, and assuring Smithers that he would send him, God willing, six drawings within the next two months 'for some small and quite possible work.' The *Maupin* was not shelved, but *Volpone* had taken its place as his chief preoccupation. It would be a 'stunning' book.

Will Rothenstein called to see his friend, and found him much changed, 'less in appearance – he had always looked delicate – than in character and outlook. All artifice had gone; he was gentle and affectionate,' and Rothenstein realized now how much he cared for him. Beardsley told him that he was full of remorse at having supplied Smithers with so many erotic drawings. Perhaps, Rothenstein commented, some would say that the old Beardsley was the true Beardsley – but, 'true as he had been to a former self, the new Aubrey would have been true to a finer self'.

The Paris weather was becoming cold and foggy. On 20 November, after travelling by day and spending a night at Marseilles, Beardsley and his mother arrived at the Hôtel Cosmopolitain, Menton, a little way out of the town on the hillside. 'The journey nearly did me,' he told Smithers, adding '(a little blood at Dijon)'. But his room was quite palatial – '*Such* sun. I must prosper' – and Menton was less loathsome than he expected. His one complaint was about the mosquitoes. They made havoc of his face, despite nets and curtains.

As so often, a new location revived him for a little, and the new project for 'Ben Jonson's adorable and astonishing *Volpone*' filled his mind. He said nothing of this to Raffalovich, for the quarterly £100 was intended to relieve him from the need to work. He planned a scheme of drawings in detail – there were to be twenty-four – and promised a line drawing for the prospectus. His letters to Smithers were full of instructions and questions about the block-maker, the paper, the cover, the exact page-size. Dowson was engaged as editor, and Vincent O'Sullivan was to provide a preface. For a limerick that Smithers sketched out, Beardsley reminded him that 'Volpone' rhymed with 'Mentone', and proposed that the last line should end with 'stony' (broke).

Smithers even floated the prospect of a new magazine, to be called *The Peacock*, a successor to *The Savoy*, with Beardsley as editor. This can scarcely have been a realistic invitation, but Beardsley replied, apparently seriously, that he would edit it 'if it is *quite agreed that Oscar Wilde contributes nothing to the magazine anonymously, pseudonymously or otherwise*'. In a later response he commented that it must be edited with a 'savage strictness': 'Let us give birth to no more little back-boneless babies.' On the art side, it should attack unflinchingly the Burne-Jones and Morrisian medieval business, 'and set up a wholesome seventeenth- and eighteenth-century standard of what picture making should be' – as his work on *Volpone* demonstrated. The critical element should be paramount – he invoked the names of Jeffreys and Gifford, editors of *The Edinburgh Review* and *The Quarterly Review* respectively. He had travelled a long way, both artistically and critically, from *Morte Darthur*.

He made a few friends in Menton, such as Joseph Tyler, the Egyptologist. Two priests visited him regularly, Abbé Luzzani and Father Orchmans, and the curé, he told Raffalovich, was an old dear. But he was leading an even more secluded life than usual, with the slow progress on *Volpone* his chief interest. 'The *Volpone* gets better and better with each drawing,' he told Mabel, 'Smithers has just sent me the cover (gold and blue) and it looks gorgeous.' In this mood he could look forward, even to the extent of reporting that his Menton doctor had suggested he might go to Dieppe in the summer. As for the proposed new quarterly, he was not really interested unless Smithers made it a Catholic magazine. 'I believe firmly a well-conducted Catholic quarterly review *(quite serious)* would have buyers,' he wrote to Mabel, adding, more realistically, that Smithers would 'want a lot of talking to' before he took it up.

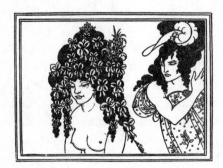

Lysistrata Defending the Acropolis
Detail of a 'bad drawing' from *Lysistrata*, published by John Lane in a collection of Beardsley's work in 1901, three years after the artist's death.

Now, in the last weeks of January 1898, he became seriously ill. He excused delay on the final initials of *Volpone*, and in answering letters, on a 'beastly attack of rheumatism' in his right arm. After 26 January he never left his room or dressed completely, according to his mother. The vile attack, he could confide to Pollitt, had left him an utter wreck 'and quite incapable of work ... Heaven only knows when I shall be able to work again.' Ellen Beardsley wired for Mabel, who left her engagement at the Garrick Theatre to join her brother. There were now two nurses to help her mother through the last days. Aubrey was 'touchingly patient', Mabel wrote to Ross, 'and resigned and longs for eternal rest. He holds always his crucifix and rosary. Thank God for some time past he has become more and more fervent.'

The battle between Beardsley's art and his religious faith is set out starkly in a last letter he wrote to Smithers:

Jesus is Our Lord and Judge

Dear Friend,
I implore you to destroy *all* copies of *Lysistrata*
and bad drawings. Show this to Pollitt and
conjure him to do same. By all that is holy *all*
obscene drawings. In my death agony.

Beardsley died, his suffering relieved by morphia, on 16 March. There was a Solemn Requiem Mass in Menton cathedral, and then, in his mother's words:

under a blue cloudless sky the solemn procession
(for nearly all in the hotel followed) mounted the
hill to the lovely cemetery, in very truth a Via
Dolorosa, and there he was laid to rest in just
such a lovely spot as he would have chosen.

In London that May, there was a Requiem Mass at the Jesuit church in Farm Street, arranged by Raffalovich and Robert Ross, with Chopin's *marche funèbre*.

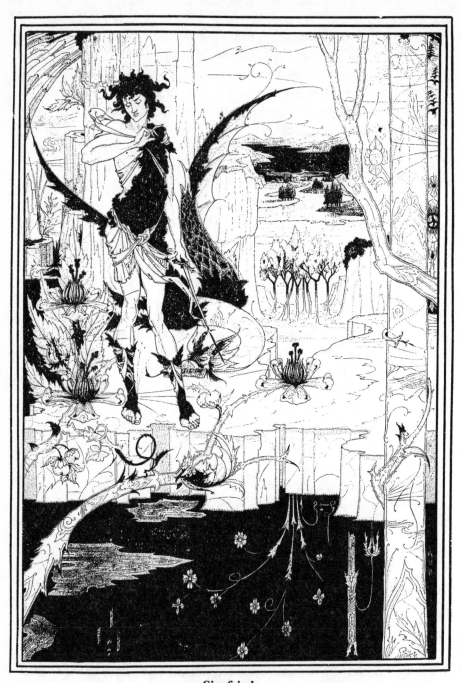

Siegfried
A drawing of 1893 illustrating Act II of Wagner's
opera, an early work in which the influence of Burne-Jones
and the Pre-Raphaelites is apparent.

EPILOGUE

〜∾〜

AUBREY BEARDSLEY MADE a vivid impression on his contemporaries, an impression as individual and distinctive as his own designs, and one accompanied by both admiration and a sense of discomfort bordering on distaste. As with Oscar Wilde, Beardsley's personality – or at least his carefully cultivated public image – was intricately bound up with the way he was received, so that much of the assessment of what he achieved seems also to be a judgement on what he stood for, or on what people thought he stood for.

It is unusual for an artist to arouse such powerful reactions on the basis of a comparatively small body of work, much of which was initially reproduced in restricted or ephemeral forms: expensive books, limited-edition prints, billboard posters, quarterly magazines (even if these were bound in yellow boards). One might have predicted that the fashion for Beardsley would disperse as rapidly as it had materialized. Instead, his impact has remained as potent as it was in the yellow eighteen nineties. His work has been widely and repeatedly reproduced, something which his chosen medium and technique make easy. His individual style and tone have continued to be a reference point within an international context.

Beardsley has always been an icon for the artistic community, and writers as diverse as D. H. Lawrence and William Faulkner have given him an extended cultural power. The 1966 exhibition organized by Brian Reade at the Victoria & Albert Museum in London brought Beardsley emphatically back into the wider public consciousness, and he became a cult figure for the late 1960s, especially on the West Coast of the United States. So far from being a passing fashion, as his early detractors prophesied, his work

107

survives within any rational survey of modern art entirely on its own terms and merits.

Beardsley's ambivalent meaning within English culture was clearly indicated in 1966 when, while the public queued to see his art in the Victorian & Albert Museum, a dealer was charged with selling obscene material – the same art – in the same city. It was as if the dull mind of the law had finally understood Roger Fry's memorable, damning description of Beardsley as 'the Fra Angelico of Satanism', and decided to call him to judgement.

What was it about Beardsley's work that upset people so much? They must, surely, have been objecting to his treatment of sexuality. His 'obscene drawings' are, in fact, few, but there are many in which an extremely unreticent and unorthodox view of sex is hinted at. On his walls in Cambridge Street were Japanese prints, 'all of them indecent, the wildest visions of Utamaro'. Most of Beardsley's drawings (and most of his writings) are intentionally ambiguous, capable of being read in several ways. Their multi-layered nature is essential to his method. Like a Japanese woodblock print in which it may not at first be understood that the setting is a brothel, Beardsley's images embrace a particular attitude to the experience of 'the floating world'. Just as the Japanese prints he admired explored the theatre, the brothel, literature, so Beardsley's subject matter evoked aspects of social and cultural life that the Victorian Establishment preferred not to be showcased in such a sardonic and suggestive a manner, and, even worse, with a parodic humour poised on the edge of caricature.

Fry argued that 'Beardsley's moral perversity actually prevented him, in spite of his extraordinary specific talent for design, from ever becoming a great designer … the finest qualities of design can never be appropriated to the expression of such morbid and perverted ideals; nobility and geniality of design are attained only by those who, whatever their actual temperament, cherish those qualities in their imagination.' Fry's essay, originally a piece in the *Athenaeum* on the 1904 Beardsley exhibition at the Carfax Gallery in London, must rank as one of the least objective reviews in the history of art. Fry ignored the fact that Beardsley was, essentially, a collaborative artist, whose genius lay partly in his elusive interaction with the texts he illustrated, or within the context to which he was contributing,

magazine, poster, book; and partly in the fierce originality of his own mind, and the power and control of his line. He looked, not at nature, but at art and literature, music and theatre, and he worked outwards to express his own vision and personality. His was an art superbly conceived for mechanical reproduction in an industrialized, consumer society, created not in a studio with a north light, or from an easel out of doors, but behind drawn curtains by candlelight: an art of the interior, in tune with the darker areas of the subconscious.

Beardsley was transparently influenced by other artists and styles. His compressed, feverish working life ensured that he went through them rapidly, taking what he wanted and moving on. Burne-Jones and the Pre-Raphaelites lie behind 'Siegfried', William Morris behind the *Morte Darthur* designs, Whistler and Japanese woodblock art behind Salome's 'Toilet'; Toulouse-Lautrec, Greek vase painting, Mantegna, Watteau are reference points for other phases of his art. The eclecticism in Beardsley's work both enriches and confuses: he borrowed, transformed and manipulated so fluently that it is hard to uncover a definite pattern, though in a drawing such as the frontispiece to *The Wonderful History of Virgilius the Sorcerer*, the debt to Japanese art is dominant. Elsewhere there is an unevenness, even a restlessness, which stems from Beardsley's urgent search to perfect his style, and from his sense of what was appropriate for the particular demands of the job he was engaged on: for example, one can note the contrast between the controlled baroque cover design for Vincent O'Sullivan's *The Houses of Sin*, and the much more ornate decorations for the title-page and letters for *Volpone*, all done within the last few months of his life.

Chapter-heading from *Le Morte Darthur*
This has echoes of William Morris.

Beardsley was an unusual decorator or illustrator in that his designs on, or between, the covers of a book usually

**The Wonderful History of
Virgilius the Sorcerer**
Frontispiece to the book
published in 1893, one of
Beardsley's most Japonesque
drawings.

interpret the text, as an especially astute critic or commentator might do: the critic, literally, as artist. In contrast to the subtle tact of a Charles Ricketts, Beardsley's designs open up the range of meanings, including meanings that the author might not wish to be made so explicit. The most obvious example of this tendency is Wilde's *Salome*; but the images and layers of meaning in *The Rape of the Lock* or *Lysistrata* come from an intellect energetically alive to the potential of the text.

Beardsley fed off the literary and theatrical mediums – Juvenal, Wagner, Gautier – and he saw the book as a theatre of the mind. The book, its appearance and feel, was a work of art in itself, and the act of reading an aesthetic experience like viewing a picture or a play, an entry point from innocence into experience. It is no accident that books feature so prominently in many of Beardsley's drawings – books on the little tables next to Salome that frame her toilette; books, naturally, in designs for bookplates and booksellers' catalogues; books stacked outside a shop window. The apparently mundane act of picking up, glancing, perhaps buying a book becomes something dangerous; and mostly it is a woman who is

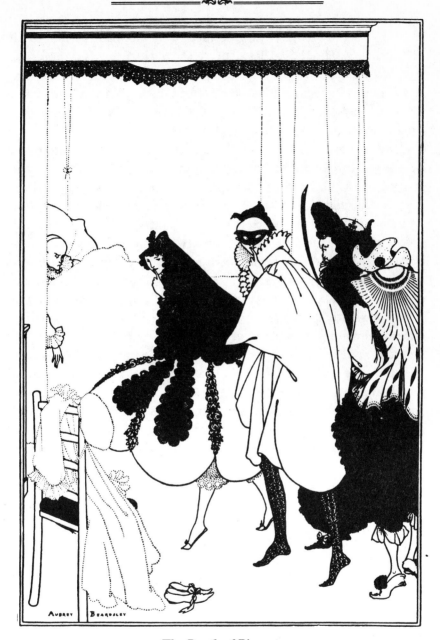

The Death of Pierrot
Reproduced in *The Savoy*, No. VI, October 1896.
The characters of a *commedia dell'arte* company –
Columbine, Harlequin, Pantalone, the Doctor – tiptoe
across the stage towards Pierrot's deathbed. The
slippers are discarded; the figures approach, asking for
silence; there is nothing to be said.

reading, about to read, or, in the case of the suppressed design for Volume V of *The Yellow Book*, be read to. Beardsley's women are intellectually and sexually on the point of freedom: New Women, and instantly recognizable as such, whether they gaze at the viewer from the pages of *Morte Darthur*, the cover of *The Yellow Book* or from a hoarding in the Charing Cross Road.

The theatre was a central and constant preoccupation for Beardsley. From his early school appearances at Brighton, and his skits, parodies and cartoons of his teachers – shades of Alfred Jarry – through The Cambridge Theatre of Varieties in Pimlico, written, produced and performed by himself and Mabel, and his preoccupation with the figure of Pierrot, and with the 'Comedy-Ballet of Marionettes', there was no form of theatre that did not attract him. He loved Wagner, and farce; he illustrated plays and drew actresses. Even his treatments of subjects not directly concerned with drama, such as Gautier's *Mademoiselle de Maupin*, have an inherent theatricality, with characters looking out at an invisible audience, from within a frame. The theatre was both the medium and the metaphor that offered him the richest set of possibilities. In his illustrations for *Salome* the images may be seen in part as design and in part as the concepts of a potential director such as Edward Gordon Craig: ideas for staging. It would have been difficult to achieve those ideas in the contemporary English theatre. But Jarry's *Ubu roi* was staged in Paris by the same director, Aurélien Lugné-Poe, who presented the première of *Salome*, with Beardsley in the audience. W. B. Yeats's famous reaction to Jarry was 'After us the Savage God'. Beardsley's interpretation of *Salome* anticipates Antonin Artaud's Theatre of Cruelty, and looks forward to the innovations of Diaghilev and Jean Cocteau.

After Beardsley's death, Wilde wrote to Smithers to order a copy of a drawing of Mademoiselle de Maupin for Diaghilev, who collected Beardsley's work. (He was the same age, and had met him in Dieppe in 1897.) Beardsley was a major influence on the Russian art journal Diaghilev fostered, *Mir Iskusstva* (The World of Art), and on the work of Konstantin Somov, Alexandre Benois and Léon Bakst. His potential as a theatre designer was realized, at one remove, in productions of the Russian ballet such as *La Tragédie de Salome*, for which Serge Soudeikine's designs in purple, black and

silver were clearly indebted to Beardsley, or in Bakst's designs for *La Légende de Joseph*. Arnold Schönberg's *Pierrot Lunaire*, featuring a woman reciting in front of a Japanese screen, was a reflection of the Beardsley manner. More recently, the black-and-white *Importance of Being Earnest* at the Lyric, Hammersmith, in 1930, designed by Michael Weight, Visconti's 1967 *La Traviata*, and Steven Berkoff's 1989 National Theatre production of *Salome* all took their visual frame of reference from Beardsley. In *haute couture* his line can be traced in the work of Paul Poiret. In English writing, his manner, as expressed in *Under the Hill*, is everywhere present in the novels of Ronald Firbank, and in the prose of Evelyn Waugh. He is a shadowy presence, too, in Yeats's poem sequence, 'Upon a Dying Lady', written about the last days of Mabel Beardsley, when Charles Ricketts brought her, as a distraction, a 'new modelled doll' based on Aubrey's drawing for *Mademoiselle de Maupin*:

> We have given the world our passion,
> We have naught for death but toys.

Beardsley's specific impact on other artists was widespread. In America, it could soon be seen in the posters of Will Bradley; and in Glasgow, during the full flowering of British Art Nouveau, Charles Rennie Mackintosh and the Macdonald sisters acknowledged his influence. In the nineteen-sixties Lord Clark made more sweeping claims, suggesting Beardsley's influence 'on the pioneers of modern art', including Munch, Klee, Kandinsky and Picasso; and quoting from Julius Meier-Graefe's *Modern Art* this judgement on Beardsley's work: 'Our utilitarianism was never rebuked in stronger or haughtier terms.'

Such a statement, directing us to the overall force of the artist, is more important than the fascinating but inevitably frustrating game of tracing lines of influence. Beardsley's achievement continues to make a powerful impact and, as time passes, the sharpness of his vision and the individuality of his style move him out of a localized context within 'the Beardsley years' and into the mainstream of the Modern Movement.

BEARDSLEY'S WORKING METHODS

BEARDSLEY IS UNUSUAL because his work was largely designed to be experienced through reproduction, and because most of it was executed in black and white. He did experiment, twice, with oils, and very occasionally applied colour-washes to his drawings. He also used bold blocks of colour for his posters, and in terms of book design – as with *The Yellow Book* – colour was obviously important. But his characteristic medium was Indian ink and his designs were reproduced by line-block, as they were for *Le Morte Darthur*, for example. This process represented a direct challenge to the more expensive wood-block method employed by William Morris for the Kelmscott Press. As Joseph Pennell wrote in *The Studio*, in April 1893, 'he has recognized that he is living in the last decade of the nineteenth century, and he has availed himself of mechanical reproduction for the publication of his drawings'.

Robert Ross and William Rothenstein, among others, left full descriptions of Beardsley's working methods, and Brian Reade, in particular, has analysed these closely. Beardsley effectively used only one piece of paper for each picture. He sketched everything in pencil, at first covering the paper with apparent scrawls – constantly rubbed out and blocked in again – to indicate the general rhythm and composition and balance. Next, according to Rothenstein, he drew 'with firmer pencil lines the main design'. Then he drew the final pen lines and masses over the pencilled lines, using Indian ink, before erasing or obliterating anything he did not want. In Ross's words, 'the whole surface became raddled from pencil, indiarubber and knife; over this incoherent surface he worked in Chinese ink with a gold pen, often ignoring the pencil lines, afterwards carefully removed. So every drawing was invented, built up, and completed on the same sheet of paper.'

He used, mostly, Whatman papers, slightly rougher than the smooth Bristol Boards that might have made the line-block maker's job easier. He moved from fine 'hairline' etching pens to the popular Gillott No. 1000 pen, before having one made to his own design, with a gold nib and fitting set in a black wooden handle – the pen that fell to the floor just before he died. Brian Reade has described Beardsley's kind of drawing as 'partly calligraphic, though not

actual calligraphy', drawings executed with the pen held close to the nib. These methods suggest extraordinary concentration and almost obsessive control, but also a sense of continuously flirting with danger – sometimes, he told Yeats, he would drop a 'blot' of ink on an area intended to be a black mass, then swirl it and 'shove it about till something comes'.

Gradually, Beardsley extended his sense of perfection to the reproduction of his designs (Pennell described him as 'the Master of the Line Block'). He acquired confidence in Carl Hentschel, the head of a firm specializing in zinc line-block printing, who frequently worked for John Lane. Beardsley's later letters to Smithers contain instructions to plate-makers and publisher, and he insisted on seeing proofs. 'For the prospectus' (of *Volpone*), he wrote to Smithers from Menton, ' I want you to use a soft paper with plenty of warmth in it so that the drawing may look as rich and velvety as possible.' The drawings for the initials 'V' and 'M' were in pencil – 'Please implore and conjure the blockist to treat them with the utmost care as the least touch will make a smudge, and the least smudge will spoil the picture.' The *Volpone* designs were reproduced by photogravure.

Paradoxically, as Beardsley grew weaker, his style was modified in the direction of greater elaboration: he tended to fill in more and more of his chosen frame, embroidering and decorating, in an impulse that required even more effort and concentration from himself, and that seems almost to be a self-imposed reaction to his early fluent mastery of pure line.

PUBLICATIONS WITH ILLUSTRATIONS BY BEARDSLEY

The Studio, vol. I, no. 1 (April 1893).

Bon-Mots of Charles Lamb and Douglas Jerrold. Edited by Walter Jerrold with grotesques and vignettes by Beardsley (J. M. Dent, London, 1893).

Bon-Mots of Sydney Smith and R. Brinsley Sheridan. Edited by Walter Jerrold with grotesques and vignettes by Beardsley (J. M. Dent, London, 1893).

Bon-Mots of Samuel Foote and Theodore Hook. Edited by Walter Jerrold with grotesques and vignettes by Beardsley (J. M. Dent, London, 1894).

Le Morte Darthur. By Sir Thomas Malory with designs by Beardsley (J. M. Dent, London, 1893-4).

Keynotes. By George Egerton (Elkin Mathews and John Lane, London, 1893; Roberts Bros, Boston, 1893). 'Keynotes' is the title of a series of novels and stories published by Lane. For most of them Beardsley designed the front cover and title-page, and for some an ornamental key incorporating the author's monogram.

Lucian's True History. Translated by Francis Hickes, illustrated by William Strang, J. B. Clark and Aubrey Beardsley (Lawrence and Bullen, London, 1894).

Salome. Translated from the French of Oscar Wilde, pictured by Aubrey Beardsley (Elkin Mathews and John Lane, London, 1894; Copeland and Day, Boston, 1894). The edition of 1907 includes two additional illustrations.

The Yellow Book, vols I and II (Elkin Mathews and John Lane, London, 1894; Copeland and Day, Boston, 1894); Vols III, IV and V (John Lane, London, 1894-5; Copeland and Day, Boston, 1894-5). Beardsley's work features in vol. I (April 1894), vol. II (July 1894), vol. III (October 1894) and vol. IV (January 1895). In vol. V Beardsley's work was removed except, by mistake, for the design on the back cover and spine.

The Works of Edgar Allan Poe (Stone & Co., Chicago, 1894-5). Beardsley's illustrations first appeared only in the ten copies of the Japanese paper issue; they were republished in 1901.

Pierrot's Library (John Lane, London, 1896). Beardsley's designs appeared on the front cover, spine, title-page and endpapers of this series, published by Lane together with Henry Altemus of Philadelphia and then with Rand-McNally and Co. of Chicago.

The Savoy, nos 1-8 (January-December 1896).

The Rape of the Lock. By Alexander Pope with illustrations by Beardsley (Leonard Smithers, London, 1896).

The Lysistrata of Aristophanes. Illustrated by Aubrey Beardsley. (Leonard Smithers, London, 1896). Published for private distribution.

The Pierrot of the Minute. By Ernest Dowson (Leonard Smithers, London, 1897). Cover design, frontispiece, initial letter, vignette, and *cul-de-lampe* by Beardsley.

A Book of Fifty Drawings by Aubrey Beardsley. Iconography by Aymer Vallance (Leonard Smithers, London, 1897).

Six drawings Illustrating Théophile Gautier's Romance Mademoiselle de Maupin by Aubrey Beardsley (Leonard Smithers, London, 1898).

Ben Jonson his Volpone: or the Foxe (Leonard Smithers, London, 1898). Critical essay on Jonson by Vincent O'Sullivan, eulogy on Beardsley by Robert Ross. Frontispiece, five initial letters and cover design by Beardsley.

A Second Book of Fifty Drawings by Aubrey Beardsley (Leonard Smithers, London, 1899).

The Early Work of Aubrey Beardsley (John Lane, London and New York, 1899).

The Later Work of Aubrey Beardsley (John Lane, London and New York, 1901).

An Issue of Five Drawings Illustrative of Juvenal and Lucian (Leonard Smithers, London, 1906). Published for private distribution.

Under the Hill and Other Essays in Prose and Verse by Aubrey Beardsley (John Lane, London, 1904). Sixteen illustrations by Beardsley.

Under the Hill. Completed by John Glassco (The Olympia Press, Paris, 1959; New English Library, London, 1966).

INDEX

FURTHER READING

Benkovitz, Miriam J. *Aubrey Beardsley: An Account of His Life* (London, 1981).

Brophy, Brigid *Beardsley and his World* (London, 1976).

Fletcher, Ian *Aubrey Beardsley* (Boston, Mass, 1987).

Langenfeld, Robert (ed.) *Reconsidering Aubrey Beardsley* (Ann Arbor, Mich., 1989).

Maas, Henry, Duncan, J. L. and Good, W.G. (eds.) *The Letters of Aubrey Beardsley* (London, 1970).

Reade, Brian *Beardsley* (London, 1967).

Reade, Brian and Dickinson, Frank *Aubrey Beardsley*, catalogue of exhibition at the Victoria and Albert Museum (London, 1966).

Ross, Robert *Aubrey Beardsley* (London and New York, 1909).

Snodgrass, Chris *Aubrey Beardsley, Dandy of the Grotesque* (Oxford, 1995).

Spens, Michael (ed.) *High Art and Low Life: The Studio and the Fin-de-siècle*, Studio International

Special Centenary Number, vol. 201, no. 1022/1023 Washington D. C., 1993).

Walker, R.A.(ed.) *The Best of Beardsley* (London, 1948).

Weintraub, Stanley *Aubrey Beardsley: A Biography* (London, 1967, rev. 1972 and 1976).

Wilson, Simon *Beardsley* (Oxford, 1976, rev. 1983).

Zatlin, Linda Gertner *Aubrey Beardsley and Victorian Sexual Politics* (Oxford, 1990).

ACKNOWLEDGEMENTS

Illustrations are reproduced by permission of the following: Albert Eugene Gallatin Collection, Princeton University Library, Princeton, N.J., 40 top; The Erotic Print Society, PO Box 10645, London SW10 9ZT, 82; Victoria and Albert Museum, London, 31 top right. Illustrations come also from the following publications: *An Aubrey Beardsley Lecture* by R. A. Walker (London, 1924), 13 middle and bottom left, 16 top left, 25 bottom left; *Le Morte Darthur* by Sir Thomas Malory, Foreword by John Rhys (2nd ed. London, 1909), 33, 109; *The Savoy*, no. 2, April 1896, 6; *Some Unknown Drawings of Aubrey Beardsley* by R. A. Walker (London, 1923), 50 right; *The Uncollected Work of Aubrey Beardsley* by C. Lewis Hind (London, 1925), 13 top left, 15 all, 16 middle and bottom left, 18, 28 right, 57; *Under the Hill* by Aubrey Beardsley (London, 1904), 25 top left. All other illustrations are reproduced from the 1920 reprints of *The Early Work of Aubrey Beardsley*, with an introduction by H. C. Marillier, first published in London in 1899, and *The Later Work of Aubrey Beardsley*, first published in London in 1901.

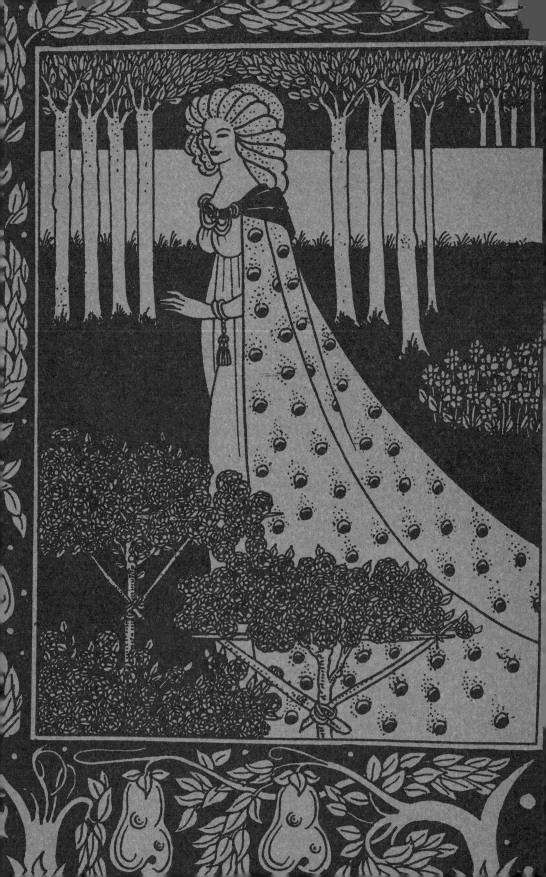